Read My Lips

A Cultural History of Lipstick

Meg Cohen Ragas & Karen Kozlowski

With an Introduction by
Véronique Vienne

CHRONICLE BOOKS
SAN FRANCISCO

For our mothers, Polly and (in memory) Patricia

Printed in Hong Kong

Library of Congress Cataloging-in-Publication Data:
Cohen Ragas, Meg.
Read my lips : a cultural history of lipstick / by Meg Cohen Ragas & Karen Kozlowski.
p. cm.
Includes bibliographical references.
ISBN 0-8118-2011-4 (hardcover)
1. Lipstick—History. 2. Lipstick—Social aspects.
I. Kozlowski, Karen. II. Title.
GT2340.C64 1998
391.6'3—dc21
97-46747
CIP

Cover + book design: Slatoff + Cohen Partners Inc.
Cover photograph: Thomas Heinser

Distributed in Canada by Raincoast Books,
8680 Cambie Street
Vancouver, BC V6P 6M9

10 9 8 7 6 5 4 3 2 1

Chronicle Books
85 Second Street
San Francisco, CA 94105

www.chroniclebooks.com

Table of Contents

Sidebars

Preface

Even women who don't wear makeup wear lipstick. It's the one cosmetic we can't live without—and can't seem to get enough of. Just ask the 92 percent of women who wear it regularly and buy an average of four tubes a year. It has the highest usage of any cosmetic product; according to a report cited in *Glamour* magazine, the average woman consumes four to nine pounds of it in her lifetime. Nothing can keep a girl from her lipstick, which may explain why it's one of the most commonly shoplifted items. The image of a woman gazing into a mirror or a compact or her reflection in a window, applying color to her lips, is one that transcends time and culture.

Part of lipstick's allure is its availability—it's an inexpensive luxury that anyone can indulge in, a quick glam fix rivaled in "I-gotta-have-it-ness" only by the little black dress (but has the advantage because it's cheaper). Even during the Depression, when food and other daily necessities were scarce, women still found money for the single cosmetic that would boost their morale. "The small cosmetic represented adventure, glamour, and high living at a low price," wrote Maggie Angeloglou in *A History of Makeup*. "The woman who made a new lipstick shade an excuse to linger in a luxurious atmosphere, to talk over and then make her choice, and to daydream all the

way home, was a comforted woman." For a small price—as little as $1 a tube for a drugstore brand—lipstick offers a big reward. And for those willing to spend a little more—up to $25 for a high-end department store number—they can have the added satisfaction of owning the Rolls Royce of lipsticks. (Most women may not be able to afford a Chanel suit, but they can certainly have a taste of the good life with one of Coco's shades.)

For all its simplicity, lipstick carries a huge responsibility: It makes a first impression and leaves a lasting mark. It's a quiet surprise that speaks volumes about the wearer—announcing a mood, extending an invitation, sealing a deal. More than mascara or foundation or eye shadow, lipstick is loaded with meaning and steeped in symbolism.

It makes a woman feel like a woman, which is why we've chosen to celebrate its rich history.

L.W. Schermerhorn

Meg Cohen Ragas and Karen Kozlowski
San Francisco, 1997

Introduction

I never leave home without my Swiss Army knife and a tube of lipstick. As far as I'm concerned, they're the only two weapons a woman needs. The knife I seldom use—its presence in my bag is mostly symbolic. The lipstick, on the other hand, truly empowers me. More than its rich color, luscious texture, or creamy consistency, it is the thing itself—the slender rod in its jeweled case—that makes me feel confident and secure.

Just try this test: At the end of a meal in a restaurant, absentmindedly reach for your lipstick, uncap it with a quick nudge, twist the wand out of its cartridge, and stare at it briefly. You'd think you pulled a gun. All eyes are on you. Sigh wistfully and look up. How so much drama can be contained in such a small gesture, I don't know. But there you have it. As Teddy Roosevelt used to say, if you want to assert your authority, "speak softly and carry a big stick."

A purse-size magic wand is not unlike that other "big stick" we carry at all times—namely our quick tongue. Unfortunately, many of us have been told that we must refrain from flaunting our innate flair for words. In my French family, teenage girls were supposed to hold their tongues, particularly around grown men. I was no Lolita, but I knew that this respectful silence

was fraught with sexual innuendos; being acquiescent was considered the ultimate feminine virtue. I may never have known the pleasure of wrapping my lips around substantial thoughts if it hadn't been for the buttery, vanilla-scented kiss of a glorious Guerlain lipstick. All it took was a little pink emollient for me to wake up from my verbal slumber. I was never tongue-tied after that first visit to the cosmetics counter.

The similarities between lipstick and tongue are more than coincidental. Both are shapely, moist, and sticky. They are also both retractable—a characteristic that makes them disturbingly suggestive to most men. Last but not least, they both must be used sparingly in polite society. In its metal sheath, the waxy lanolin stick is reminiscent of this slippery bundle of fibers, nerves, and buds that enables us to taste, chew, swallow—and, most important, to speak up. Silenced for centuries, women have learned to wield their lipsticks as a substitute for speech. Without saying a word, they can make a statement with the color and shape of their painted lips.

If and when we decide to unbutton our lips and voice our opinions, our lipstick acts as a speech coach. The lush sensation of the lubricant on our mouths encourages us to weigh our words and articulate them carefully. As we enunciate, the scrumptious balm stretches and constricts, stimulating tiny muscles that radiate from the lips to our jaws, cheeks, nose, eyes, and ears. Our discourse takes on a well-rounded physical dimension. What we say is invested with the total awareness of our five senses.

Which explains the appeal of the quick lipstick fix. When I was gainfully employed, I used to advocate lipstick breaks instead of coffee breaks among my female coworkers. Under my leadership, four or five of us would troop to the ladies room, swinging our makeup kits. Give me your tired, your unlipsticked, your huddled masses yearning to breathe free. We would emerge ten minutes later with lips highlighted in red freedom paint—no longer feel-

ing like the wretched refuse of some teeming corporate shore. Emboldened by my success as Liberty Enlightening the World, I tried to convince the same girlfriends to apply their lipstick in public—a gesture I insisted was regal when performed in plain view, without a mirror. I have yet to make a single convert.

Social etiquette notwithstanding, I wish women would stop running to the bathroom or hiding coyly behind their compacts to color their lips. Imagine fancy restaurants full of ladies-who-lunch wagging their uncapped Borghese and Chanel lipsticks while fighting for the bill. Then, without batting their eyelashes, they tilt their miniature batons toward their faces. They look ever so serious as they slowly laminate their mouths with layers of crimson veneer. The moisture-rich formula glides effortlessly along the contour of their lips. As they bear down on their lipstick to define the curve of their smiles and the angle of their pouts, one can't help but watch in anticipation. When they do speak, they will not feel compelled to raise their voices. The world will be all ears.

Speak softly and carry a lipstick.

—Véroniqe Vienne, author of *French Style* and *The Art of Doing Nothing*, is a freelance writer living in Brooklyn. She wears Yves St. Laurent no.19.

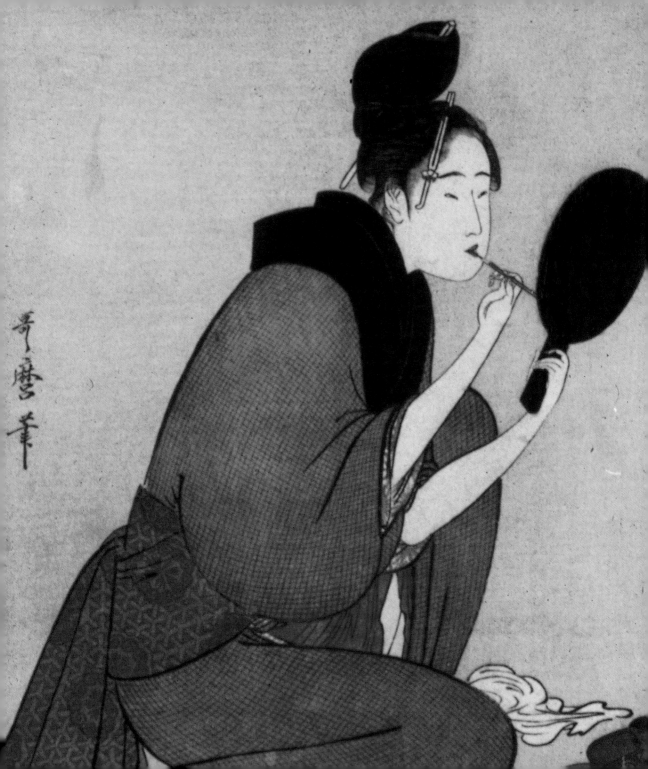

Cleopatra used henna and carmine. Queen Schub-ad of Ur favored crushed red rocks. Poppaea Sabina, the wife of Roman Emperor Nero, experimented with ochre, iron ore, and fucus. Since cavewomen first discovered that their club-wielding counterparts liked them better with berry-stained lips, lipstick has become the most celebrated and versatile cosmetic in history. Its colorful evolution has been documented through time, as lipstick emerged from a jumble of primitive ingredients into the sophisticated product we use today.

Lipstick, B.T. (Before Tube)

Since the first cosmetics cases were discovered in a five-thousand-year-old Sumerian tomb near Ur, lipstick, even in its most rudimentary form, has made a lasting impression. The ritual of lip painting can be traced back to an image on an ancient Egyptian papyrus scroll, which depicted a woman holding a mirror in one hand and making up her lips with the other. In the early Christian period, both men and women reveled in the art of painting their lips, and making herself up was considered part of a wife's "moral obligation" if she wished good health and a long life for her husband. It was fash-

Ancient Egyptian men and women were so enamored with painting themselves that they went to the grave supplied with lip rouge for the afterlife.

69–30 B.C.
Cleopatra paints her lips with henna and carmine

6th century
In Spain, lip rouge is popular among prostitutes and the lower classes

17th century
Lip painting is denounced by the clergy

ionable for Greek women of the fourth century B.C. to color their lips with a rouge made of vermilion and vegetable substances, such as seaweed and mulberry. And Palestinian women of the second century A.D. were quite daring in their color choices: They alternated between a bright red-orange shade and a deep, almost purple, raspberry one.

In the Middle Ages, the use of lipstick was seen as a class distinction, a perception that continued through the beginning of the twentieth century. In sixth-century Spain, lip rouge was popular among prostitutes and the lower classes; upper-class women shied away from heavy painting. By the thirteenth century, however, lip painting was fashionable among all the classes, but Tuscan society ladies preferred a bright pink color to the masses' less sophisticated, earth-tone red. A full mouth was also admired at the time. A French poet praised lips that were "plump and redder than cochineal," and Chaucer paid tribute to a full mouth in *The Court of Love:* "With pregnant lippes thin, not fat, but ever lean / They serve of naught; they be not worth a bean / For if the base be full, there is delight." Japanese women took this to the extreme; they gilded their lower lips in order to draw their lover's gaze to them.

The Italian Renaissance ushered in a new standard of beauty. In 1540, Firenzuola, a celebrated man of letters, published *Dialogo delle Bellezze delle Donne* (Dialogue on the beauty of women), in which he declared "the mouth was to be small with medium lips, vermilion in colour and not to show more than five or six teeth—uppers only—when parted." In England, under Queen Elizabeth I, crimson-stained lips were the standard of the day (Elizabeth herself preferred a concoction of cochineal blended with gum arabic, egg white, and fig milk); in Paris, even nuns were spotted in the streets with painted mouths. Cosmetics were becoming more generally used and someone had to begin manufacturing them. A few publications from this time featured

VOGUE

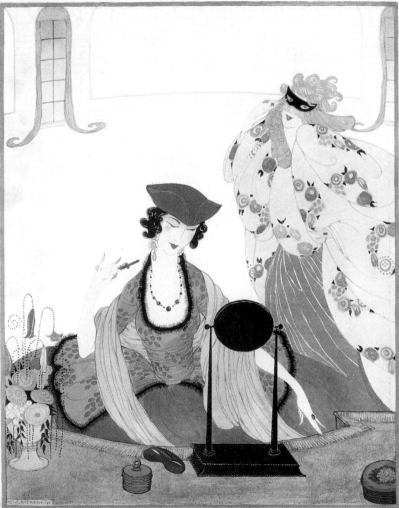

The Vogue Company
CONDÉ NAST Publisher

Lingerie and Vanity
Number

January Fifteen 1920
~ Price 35 cts

instructions and recipes for mixing various beauty concoctions. Although lipstick wouldn't be mass produced until 1915 (when American Maurice Levy invented its metal container), new formulas kept cropping up over the next few centuries.

Painting the lips went under siege in the seventeenth century, drawing increased scrutiny from the clergy and ethicists alike, who viewed it as cheating, as altering God's most precious gift. But the criticism didn't stop women from trying to achieve what they believed was the "ideal beauty": lips as "red as a cherry," according to the anonymous author of *How to Choose a Wife*, and as "red as rubies," in the words of the poet Robert Herrick. Men weren't morally opposed to their wives' lip painting; they viewed it more as a silly pastime than a mortal sin. They even found some of the trends of the day quite desirable. Sir John Suckling wrote of a lovely lady he admired: "Her lips were red, and one was thin / Compared with that was next her chin / Some bee had stung it newly." (Apparently, Suckling wasn't concerned whether or not the color was natural.)

Devil's Candy

By the mid–seventeenth century, lip painting was more widely accepted, although the ritual still had its detractors. Thomas Hall, an English pastor and author of *The Loathsomnesse of Long Haire* (1653), led a movement declaring that face painting was "the devil's work," and that women who put brush to mouth were trying to "ensnare others, and to kindle a fire and flame of lust in the hearts of those who cast their eyes upon them." The root of the problem lay with excessive vanity, he claimed, and called the result "the badge of a harlot." According to Hall, practitioners of this satanic act were trying to make themselves more enticing—either to snag a husband or to hold on to the one they already had.

1770
British Parliament passes a law condemning lip painting, stating that women who seduced men into marriage with makeup could be tried for witchcraft

1781
French women are using roughly two million pots of rouge a year

Hall may have been the first to introduce the idea of lipstick-as-entrapment, but it's a theme that has resurfaced again and again. Lipstick's role was expanding beyond that of beauty implement and was having greater social implications. In 1770, the British Parliament passed a law condemning lipstick, stating that "women found guilty of seducing men into matrimony by a cosmetic means could be tried for witchcraft." In Pennsylvania, a marriage could be annulled if the wife had used cosmetics during the couple's courtship. (Even as recently as August 1996, the Malaysian government of Kuala Lumpur introduced a ban against excessive use of lipstick, claiming that "such practices were a prelude to illicit sex.")

Heavy Painting

The white, "painted porcelain" look that dominated until the French Revolution was made even more dramatic by the contrast of bright, heavily rouged lips. Contrary to earlier times, it was now the ladies of the French court who painted with reckless abandon, while the prostitutes favored a more sub-dued, natural look. (In London, ladies of the evening still painted their lips with gusto.) Sir Henry Beaumont said of English women's lips at the time: "The Mouth should be small, and the Lips, not of equal thickness; . . . and with a living Red in them. A truly pretty mouth is like a Rose-bud that is beginning to blow."

The ways in which women achieved this look varied. Some washed their lips with pure brandy to make them appear redder. Others followed recipes like the one favored by society hairdresser James Stewart, which called for a half pound of "caul of mutton," four ounces of wax, four drachms of carmine, and a bit of rose color. Still others looked to *The Toilet of Flora*, published in 1775, for prescriptions for scarlet lip salves, one of which suggested adding gold leaf. In 1781, it was estimated that French women used roughly two million pots of rouge a year.

1839
Lip salve achieves its first "she's-gotta-have-it" status

circa 1860s
German teenager Charles Meyer invents a lipstick crayon for actors

1880
Guerlain produces the first commercially successful lipstick

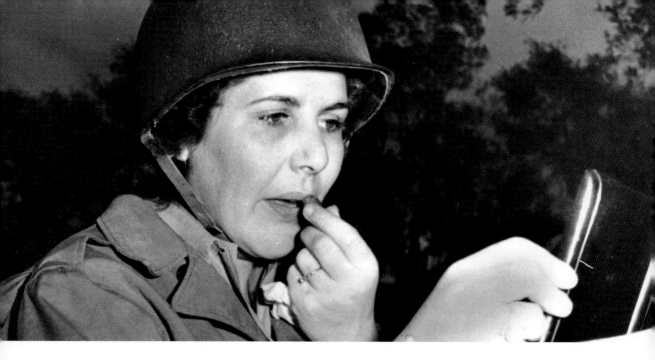

Lipstick on the Lam

As the reign of Queen Victoria tightened its grip on England, lip painting lost some of its luster. For the better part of the nineteenth century, heavy makeup was not socially acceptable and was rarely seen. Although lipstick may have been banned publicly, privately it was still a significant part of a woman's beauty regime. By 1828, a privileged few could sneak off to Paris to purchase lip pomades from Guerlain. (This company produced the first commercially successful lipstick in 1880, composed of pomade of grapefruit mixed with butter and wax.) In *The Toilet: A Dressing-Table Companion*, published in 1839, a box of lip salve was listed as one of the articles that "should be kept on the toilet table, ready for immediate use." And repressed Victorians found a way to get their color fix: They received a carnation-colored glow by stealing a kiss from rosy crepe paper.

Although the tug-of-war over lipstick's acceptability continued, the number of cosmetics being manufactured and distributed was increasing. Those who still opposed lip painting were divided into two camps: the

Above: On the U.S. Fifth Army front in Italy, WAC Private Lois Lebert of Lafayette, Louisiana, applies lipstick outside her tent, 1944

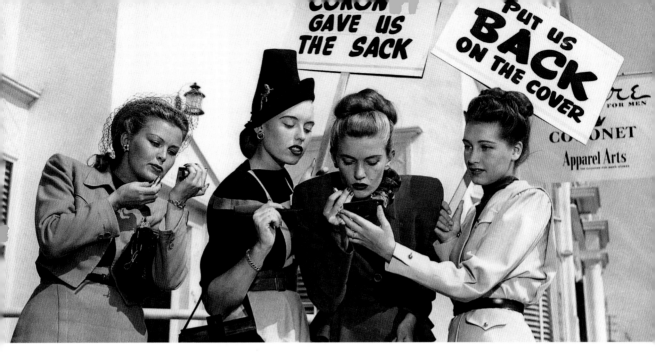

detractors who objected to it for its borderline ingredients and the detractors who believed it marred a woman's natural beauty and, in turn, a man's perception of her. Mrs. Alexander Walker warned women against the dangers of lead and vermilion in *Female Beauty*, published in 1840. And in 1858, Madame Lola Montez, an adventuress and arbiter of fashion, described the horror of painted lips in *The Arts of Beauty*: "Let every woman at once understand that paint can do nothing for the mouth and lips. The advantage gained by the artificial red is a thousand times more than lost by the sure destruction of that delicate charm associated with the idea of 'nature's dewy lip.' There can be no dew on a painted lip. And there is no man who does not shrink back with disgust from the idea of kissing a pair of painted lips." Annie Wolf, author of *The Truth about Beauty*, found red lips "inharmonious with certain temperaments. . . . Alcohol, vinegars, and red paint destroy the delicate skin, which is so much appreciated in a kiss. How often children say to ladies who kiss them: 'Your lips prick me' because the skin is rough."

The 1860s marked the end of the old prohibition against makeup and

circa 1880s
Repressed Victorians get their color fix by stealing kisses from rose-colored crepe paper

1897
The Sears Roebuck catalog begins advertising lip rouge for $.50

Above: Hollywood cover girls protest Coronet Magazine's *decision to replace models on the cover with folksy art, 1946*

By 1930, women were buying enough lipstick to reach from Chicago to Los Angeles by way of San Francisco.

the revival of cosmetics use around the world. German teenager Charles Meyer introduced Leichner's theatrical makeup, giving birth to the first lipstick crayons, and French recipes for lip salves were being duplicated at home. Professionals in the art of makeup application, known at the time as enamelers, began to turn up in abundance. Even those who disapproved of lip painting were reluctantly caving in. In 1897, the Sears Roebuck catalog advertised a wide variety of cosmetics, including a rouge described as "a harmless preparation for giving color to the cheeks and lips"; it sold for fifty cents.

Lipstick at Last: The Twentieth Century

At the turn of the century, lipstick was headed toward liberation. Advancing technology and more sophisticated marketing and advertising tactics heightened the profile of cosmetics. For the first time since ancient Egypt, makeup came to be universally accepted, both socially and morally. Lip salve, however, was still considered the least respectable of cosmetics. According to a countess's beauty book published in the early 1900s, the lips "should be of a pretty red strawberry colour, but the colour should be achieved through health, not cosmetics." The countess also spoke against the habit of biting one's lips to make them red, a practice employed by Gibson girls, who also were known to suck hot cinnamon drops to achieve a swollen effect.

Before World War I, the emphasis was more on maintaining healthy lips than on achieving an artificial glow. *Vogue* approached the task of rouging with considerable delicacy and in 1904 recommended "a perfumed lip salve which cost $.25 and was put up daintily in an aluminum case. This is an adjunct of the toilet which almost all women appreciate; it gives the lips a rich, healthy appearance and prevents their chapping or becoming rough."

1915

Maurice Levy designs the first American lipstick in a sliding metal tube

circa 1915

To make their mouths appear redder and more swollen, Gibson Girls bite their lips and suck on hot cinnamon drops

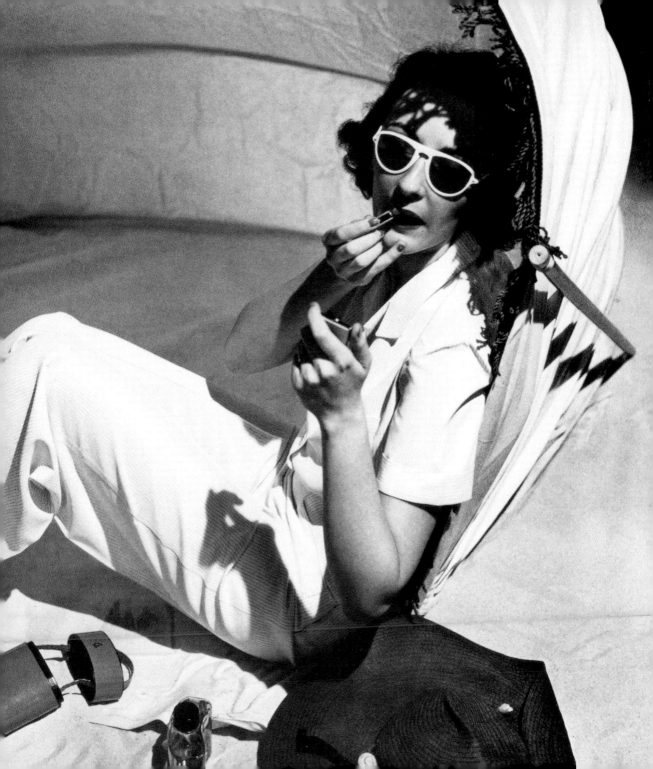

VOGUE

Beauty Issue

Summer
Fashions

Incorporating Vanity Fair

May 1945
Price 35 Cents
40 Cents In Canada

COPYRIGHT 1945, THE CONDÉ NAST PUBLICATIONS INC.

Vogue is regularly published twice a month. Because of wartime emergencies, it will be published once a month during May, June, July.

The Baroness d'Orchamps, in *Tous les Secrets de la Femme* (1907), suggested the following: "Soak the lips for at least five minutes in a glass of warm water. Dry them, then smear them with camphorated pomade. After a quarter of an hour, dry them again with a soft cloth and put on some glycerine. Unless you are seriously anemic, your lips will become as red as carmine. . . . A light sucking of the lips, a little bite, will give to them in an instant a crimson bloom."

The early 1900s marked a boom in the beauty business. Lipstick was slowly making its way into the public arena. Leaders in the industry such as Helena Rubinstein (who created her own lipsticks and rouges in response to popular demand) and Elizabeth Arden opened the first beauty parlors, offering services that ranged from facial massages to hair dressing to makeup tips. By 1908, one beauty etiquette writer proclaimed that it was okay for women "to use rouge sticks . . . openly at the table while dining out at lunch, but not at dinner." Handbags were outfitted with specially designed cosmetics accessories, including a lip rouge box, powder puff, and eyebrow pencil.

Cosmetics sales increased by 100 percent between 1900 and 1910; *Everybody's Magazine* reported in December 1915 that $15 million worth of cosmetics were being sold annually in the United States. Sales did not seem affected by the products' sometimes poisonous ingredients. (Lipstick contained more than a few shady substances.) "Yet," *Everybody's Magazine* pointed out, "there is little effective legislation to prevent the manufacturers —who are men—from poisoning and defrauding their women customers." (In fact, it wasn't until 1938 that Congress passed the landmark Federal Food, Drug, and Cosmetic Act, regulating cosmetics manufacturers by authorizing "standards of identity and quality for products, and pre-distribution clearance to ensure safety of new substances.")

This also marked the height of the flapper era, when Clara Bow (the "It" girl), Mae Murray, and Joan Crawford made cupid's bow lips, bee-stung

1924

The New York Board of Health considers banning lipstick for fear that it might poison the men who kissed the women who wore it; fifty million American women are using lipstick

1928

Max Factor introduces the first commercial lip gloss

lips, and hunter's bow lips ("the smear"), respectively, the height of fashion. Max Factor, who developed the first motion-picture makeup in 1914, credited these actresses with "helping to rout America's prejudice against lipstick." (The practice of licking one's lips to give them a shine ceased when Factor introduced lip gloss in 1928, a makeup trick originally whipped up for movie actresses.)

By 1923, the increased interest in cosmetics had necessitated improved packaging—rouge, powder, and lipstick all in the same compact—and this innovative concept attracted more customers. The rise in sales meant lower costs and lower-priced cosmetics (also due in part to the birth of the chain store) and a tube of lipstick could be had for a dime. Lipstick application was becoming an accepted and even celebrated public ritual. By 1924, it was estimated that fifty million American women were using lipstick, and cosmetics manufacturers ranked second only to food companies in the amount of money they spent on advertising.

1938
Congress passes the Federal Food, Drug, and Cosmetic Act, regulating lipstick manufacturers; of 53,000 households surveyed in the United States, 58 percent reported owning at least one lipstick (only 59 percent reported owning a jar of mustard)

Lipstick was making a lasting impression in another way as well: The mid-1920s ushered in the first of an ongoing trend of long-lasting lip colors. New York cosmetics shops featured an indelible liquid lip rouge and pomade in rose or medium red. The Parisian outfit Lescondieu offered the new product Tussy, which was not only indelible but scented. England tried to keep pace, but the London-based Primrose House could only advertise its lipstick as "practically indelible." (Truly indelible lipstick didn't hit the market until 1940, when Max Factor launched Tru-Color, the first nonirritating, long-lasting formula that didn't change color after it was applied.)

Lipstick Gets a Pardon

In the wake of the great social transformation of the 1920s, a more relaxed attitude toward cosmetics emerged, typified by books like Dorothy

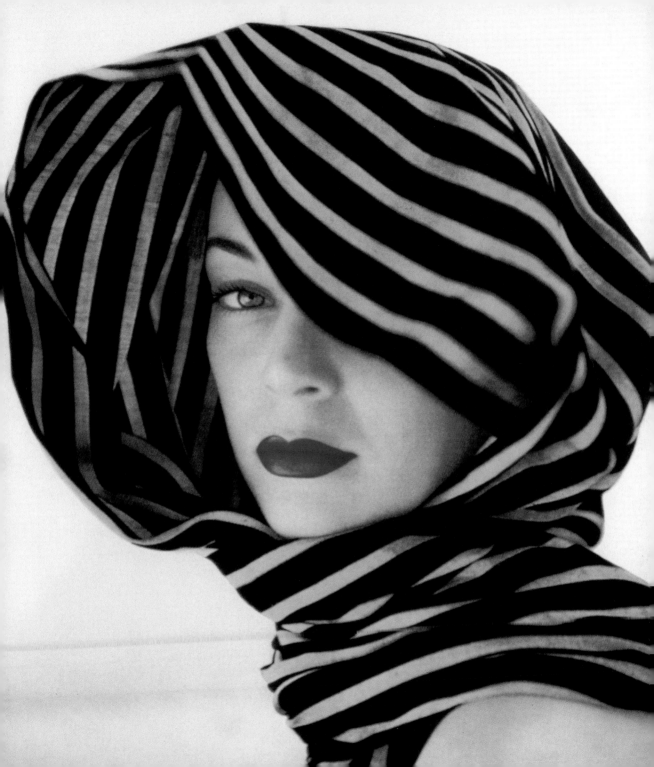

1939–1945

During World War II, certain key lipstick ingredients, such as castor oil and petroleum jelly, are in short supply; metal lipstick cases are replaced with plastic and paper

1940

Max Factor introduces the first truly indelible lipstick

Cocks's *Etiquette of Beauty* (1927), which pondered the moralities of make-up: "Oddly enough, even in modern times cosmetics still cause a lift of the eyebrows in some circles. Our older generation shudders at our younger generation's frank use of the lipstick. But that very frankness makes a lipstick virtuous! It is only an immoral motive which can make cosmetics iniquitous. And in the last analysis, immorality is doing something one is ashamed to be caught doing." Writer Alexander Black prophesied the power of the tube: "Probably the lipstick has aroused sharper critical rage than any other whimsicality of women. It can appear to have seized the feminine imagination more violently than any other specific device of fashion."

Survey results from 1929, the year Max Factor introduced the first commercial lip brush, showed that fashionable women owned at least two lipsticks, one for day and one for evening. By 1930, an advertising agency estimated that American women were using "3,000 miles of lipstick a year." A 1933 issue of *Vogue* endorsed lipstick as the most important cosmetic for women: "If we were perpetuating the gesture of the twentieth century for posterity, putting on lipstick would head the list. An ode could be written to it, and to the way in which it serves as a staff for our morale, as well as a beautifier of our faces. It has come to a point where gentlemen have even developed preferences in the very taste of lipsticks." Even the Depression was unable to slow the momentum. When fifty-three thousand households in the United States were polled in 1938, 58 percent reported that they had at least one lipstick, quite a high number when compared with the fact that only 59 percent reported owning a jar of mustard.

Lipstick suffered a slight setback in production during World War II, when key ingredients such as castor oil and petroleum jelly were difficult to obtain. When Revlon chemist Ray Stetzer heard of a warehouse full of the former in Tennessee, he headed south to perform his own quality check.

After tasting the contents of each of the forty-gallon drums of castor oil, he bought the entire stock—and spent the rest of the trip in the loo.

Revlon, like *Vogue*, understood the importance of lipstick for morale, but wartime restrictions demanded that metal cases had to be replaced, first with plastic and finally with paper, and the other cosmetic companies soon followed suit. Armand Petitjean, founder of Lancôme, refused to compromise the quality of his lipsticks; the formula remained the same, but production and distribution were limited. Washington politicians considered banning the beauty industry for the duration of the war to preserve materials, but wiser heads prevailed. (When Hitler banned makeup in Germany, the German women refused to work.)

Lipstick Finds Its Legs

As women's attachment to lipstick became increasingly evident during wartime, manufacturers seized the opportunity to market more products. In 1948, Gala of London introduced Lip Line—a long, thin lipstick in a variety of shades for outlining and coloring in the lips; it was also refillable. Colors included Cock's Comb, Red Sequin, and Heavenly Pink, names that foreshadowed the trend of playful product monikers that is still popular today. Rimmel launched the Lip Palette, a spectrum of colors packaged with a mirror and brush. Goya came out with its Grandee lipstick, which was "twice the size of ordinary lipsticks." A favorite among women on both sides of the Atlantic was Elizabeth Arden's Surprise lipstick, which had "the come-hither of pink, the persuasiveness of rose, the courage of red" and promised to turn every woman who wore it into a "softly glowing beauty."

By the 1950s, both women and girls were on a lipstick rampage; a survey of teenagers showed that two-thirds of them had been painting their lips since they were fourteen. In 1952, Revlon launched the first big-scale

1952

Revlon launches the breakthrough Fire and Ice campaign

1957

A study of American college girls shows that 99.7 percent use lipstick and own an average of two shades

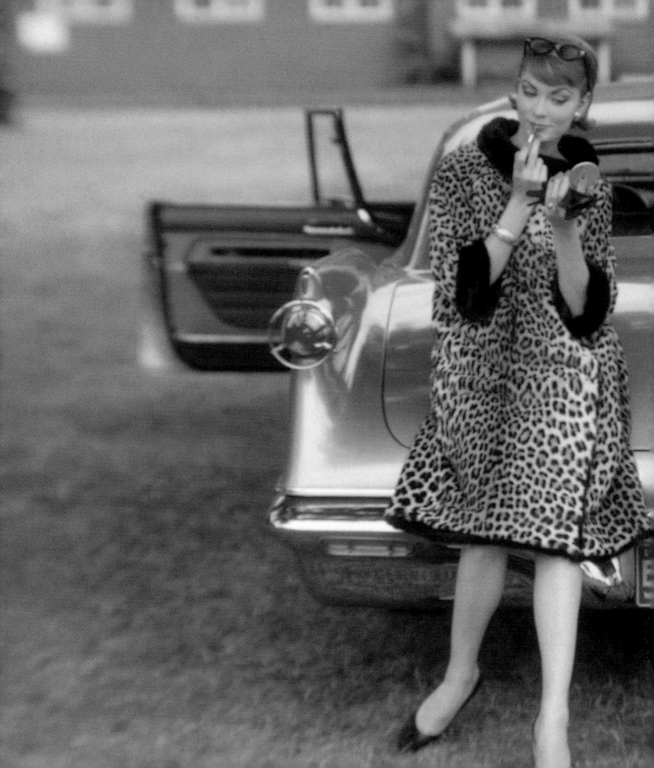

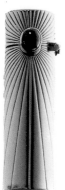

cosmetics advertising campaign of the time, Fire and Ice. Lipstick was presented as bolder, sexier, and more sophisticated than ever before. "A woman who doesn't wear lipstick," said Max Factor in a 1958 issue of *Time* magazine, "feels undressed in public. Unless she works on a farm."

Lipstick was reborn. Trends leaned toward heavily painted, brightly colored lips in pink or red; a perfectly defined silhouette was a necessity. Suddenly, if you didn't wear lipstick, you were an outcast. More females in the workforce resulted in increased cosmetics use as women strived to enhance their public appearance and, in turn, their private vanity. Inspired by the royal weddings of the decade—Prince Rainier of Monaco to Grace Kelly, Prince Aly Khan to Rita Hayworth—women equated aristocracy with beauty and felt that by imitating cosmetics rituals of the rich and famous, they, too, could have a taste of the good life. (In 1953, during Elizabeth II's ascendance to the throne, ladies on both continents favored the Queen's Coronation pink.) Lipstick also began to take its cue from fashion, and color choices relied much more on the shade of a woman's dress than on her hair color or complexion. Following in the footsteps of Germaine Monteil, a French couture designer who began manufacturing her own lipstick in 1936 after she couldn't find existing hues to match her creations, cosmetics companies looked to fashion designers to predict the shades of the moment. This trend was strongly encouraged by *Vogue*, which would introduce a color for the season and then persuade cosmetics manufacturers to supply complementary shades.

By the middle of the decade, when girls-next-door were trying to imitate the bold, glamorous looks first flaunted by Hollywood, movie stars were starting to look more and more like the girl next door. They switched to the natural look, and sported paler lips. In the December 1957 issue of *Queen's* magazine, Joan Price instructed that lipstick should be applied more subtly

1966

Mary Quant launches her line of cosmetics; white lips are all the rage in London among mods and Chelsea girls

1973

Bonne Bell introduces flavored Lip Smackers

and lean toward flame and coral tones. A study of American college girls published the same year showed that 99.7 percent used lipstick, and that of the twenty or so shades available, they owned only two—"a pink, coral, or light clear red for classes, and a deeper shade for evening." Lipstick was selling for $1 to $2 per tube and cost as little as six cents to produce.

By 1958, pale was out and bright was back—*Vogue* recommended "true-red, orange, pink-orange lipsticks." Max Factor started manufacturing Pink 'n' Orange hi-fi lipstick: "Not pink! Not orange! Max Factor's outrageous new color creation that captivated all Paris! The soft flattery of pink plus the brilliant excitement of orange—all in one shade. It's bold. It's feminine. It's the shade Paris says will make him yours." Helena Rubinstein declared her Bed of Roses lipstick "perfect for all occasions." And frosted, shimmery lips became fashionable when Gala, borrowing from the French and Italian manufacturers, began putting titanium in its products. Vivid, powerful, feminine—these characteristics were carried over into the next decade.

Lipstick out of Sight

The cultural transformations of the '60s brought a liberalism to lipstick. The explosion of lip painting in the '50s paved the way for a variety of trends that took their cues from the "youthquake" of London. Mod, in the guise of Mary Quant, ushered in the miniskirt, the high boot, and the adolescent look in makeup; in 1966, Quant debuted her own line of cosmetics for Gala in response to the new direction in fashion. She wrote in her memoir, *Quant by Quant*, "Makeup old style is out. It is used as expertly as ever but it is not designed to show. . . . Lipstick is kept to a pale gloss."

Although the beauty trends of the decade were geared mostly toward eye makeup, lipstick had its moments. The dawning of the age of aquarius was a time of "anything goes," when individual style surpassed conformity,

circa 1975
Yves St. Laurent debuts the concept of numbering lipsticks

1979
Black lipstick emerges as *the* statement of the late twentieth century

and lipstick trends reflected this revolutionary spirit. While beauty icons like Brigitte Bardot, Jean Shrimpton, and Twiggy expressed their identities with dramatically painted lips, Jacqueline Bouvier Kennedy favored a more traditional approach and tawny, subdued lip tones. Tussy advertised its Two Tone lipstick, "Lipstick with the lip liner built right in!" By the middle of the decade, heavy metallics were all the rage. In reaction to the James Bond film *Goldfinger* (1964), in which Goldfinger's secretary dies from a fatal dose of gold body painting, cosmetics manufacturers started the "gold rush." Helena Rubinstein introduced lipstick in "Three precious-metal tones . . . Bronze Rage! Silver Rage! Gold Rage! Plus three shades that hint of glint, rage with color. Pink Rage! Orange Rage! Flame Rage!" In the late '60s, mods and Chelsea girls were seen sporting white lips, negating everything that had been predictable about lipstick up until then.

The lipstick revolution continued into the '70s, with women experimenting with a variety of painting techniques, including matching their lips to their eye makeup and clothes. Revlon came out with a frosted product—Luminesque Lipfrosts—in seventeen shades, with names like String of Pearls, Salmon Ice, and Ginger Glaze. Startling, exciting colors, including deep purples and raspberrys, predominated; red glossy lips returned to the runway. Mary Quant introduced Pot o' Gloss. "This season's deep, winey lip colors put lips in sharp focus," crowed *McCall's* in 1978. Yves St. Laurent debuted the concept of assigning numbers to lipsticks; his most famous, St. Laurent no. 19, was a pure fuchsia tint favored by makeup artists. "It caught on like wildfire," said Chantal Roos, one of the line's product developers. "Nothing so violent, so ripe had existed as pure color before." (The lipstick was eventually banned in the United States because it contained a potentially cancer-causing colorant.)

There was more color in lipsticks—grayer tones in the spring, like Mary

1983
Elizabeth Arden's Lip Fix is the biggest seller in company history

1988
Revlon's Ultima II line debuts The Nakeds, heralding the return of the natural look

1994
Revlon's ColorStay hits the shelves, re-igniting the indelible lipstick revolution

○ Lipstick in Any Language

Italians apply *rossetto*, and the French daub their lips with *rouge à lèvres*. Lipstick has a global appeal—in a variety of disguises. Here's how to decode them.

Lippenstift	German	"lip pencil" or "lip crayon"
Il rossetto	Italian	"rouge"
Lápiz para los labios	Spanish	"lip pencil" or "lip crayon"
Rouge à lèvres	French	"lip rouge"
K'ou hung	Chinese	"scarlet mouth"
Kuchi-beni	Japanese	"red lips"

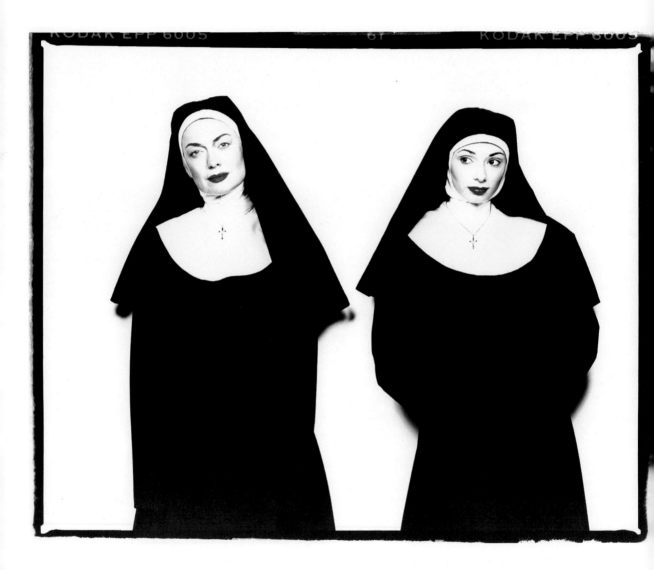

Quant's Prune Crush and Revlon's Grapevine, and brighter, true red hues in the autumn. "I knew the results would be brilliant," said Charles Revson in *Vogue* of his inspired decision to hire designers Bill Blass and Norman Norell to create two new reds for his Ultima II lipstick line. Helmut Newton's models wore blood-red lipstick, reflecting the "porno-chic" sexuality that had begun infiltrating fashion photography in the '70s. Guy Bourdin favored "rose blush and violent fuchsia lips" for his models, capturing the good girl–bad girl dichotomy that was becoming increasingly popular. Late in the decade, black lipstick, made popular by the anarchist punk movement, emerged as the icon, the statement, of the late twentieth century. "*Exciting* is the adjective that's replacing *pretty* and *beautiful* as ultimate praise for an attractive woman," Eugenia Sheppard told *Harper's Bazaar*. "Excitement is movement, noise, turbulence, and today."

Mouthing Off into the Future

The '80s ushered in the era of excess, and nothing—not even lipstick—was spared. Big makeup and big lips screamed from the pages of fashion magazines, heralding a new gaudy glamour that reflected the decadence of the time. By the end of the decade, however, lipcolor had come full circle with the introduction of nude, muted tones reminiscent of the natural look that dominated in the late '50s. Revlon's Ultima II debuted The Nakeds—a line that consisted of nothing but brown and beige makeup "for women comfortable with who they are, in control of their destiny." Women became accustomed to baring their lips again and temporarily retired their bold reds and luscious, full pinks.

While this quiet lip look continued into the '90s, several other trends surfaced as well. The lip liner revolution—the practice of lining one's lips in an attempt to make them appear larger—was popular with everyone from Madonna to Cindy Crawford. Browns continued to be leading sellers, and

1995

M.A.C. Cosmetics appoints RuPaul the spokesperson for its AIDS Fund and its Viva Glam lipstick campaign

1997

Lipstick is selected as one of twelve icons featured in the San Francisco Museum of Modern Art's exhibition, *Icons: Magnets of Meaning*

shimmers crept back onto cosmetics counters. The bottom line: Women were choosing lipstick because it looked good on them, not because it was the shade-of-the-moment. "The current trend is that there is no trend," says M.A.C. founder Frank Toskan. "It's whatever you want to be because we're finally comfortable making our own choices."

Women began wearing what they liked. The lip color palette expanded to include everything from blues to silvers to golds to yellows. And formulas changed, too. Long-lasting lipsticks that couldn't be kissed off took the industry by storm. "Chubbies" or "Sticks"—a lip liner and lipstick combined, in the shape of a crayon—appealed to the modern woman on the go. Gloss, in pots and tubes, made a huge comeback.

So what does it all add up to? According to Annemarie Iverson, beauty and fashion director of *Harper's Bazaar*, lipstick is now "more casual, a little less precise. There is no perfect definition." And no more perfect—or more appropriate—way for lipstick to head into the new millennium.

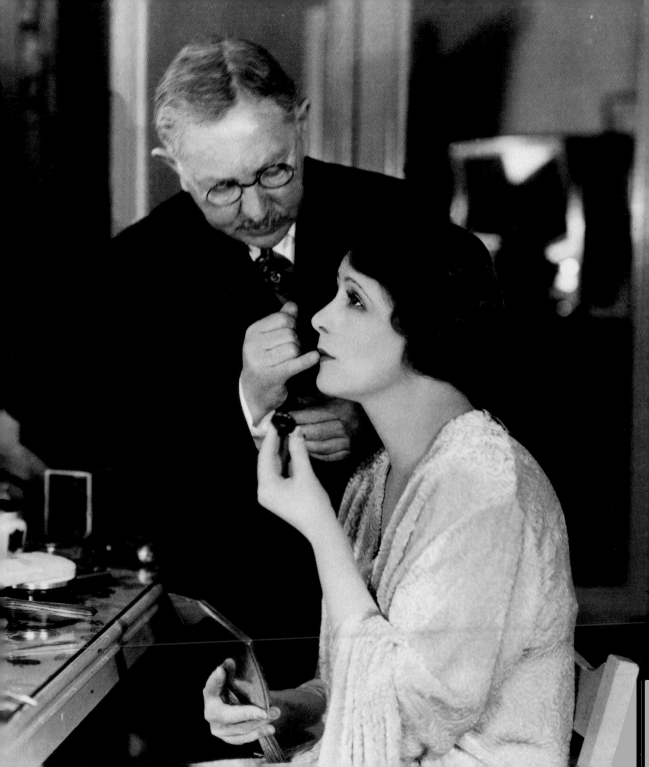

From fish scales to beeswax, lipstick is a complex recipe of ingredients that changes depending on the finish—matte, creme, glossy, or sheer. There's a lot more to that perfectly streamlined bullet of color than meets the eye. Hours, sometimes days of careful and precise mixing, measuring, and blending are needed to achieve the right shade; one pound of lipstick mass makes from one hundred to one hundred and fifty standard-size lipsticks. And no two lipsticks are exactly the same.

Lipstick ingredients fall into three basic categories: waxes, pigments, and emollients. Wax is what puts the "stick" in lipstick, and the waxes used include beeswax, carnauba, paraffin, ozokerite, microcrystalline, and candelilla. Pigment gives the lipstick its color and is made from powdered dyes such as iron oxides (deep reds, deep yellows, or black) and titanium dioxide (white). The emollient category is the most diverse; almost any kind of oil can be put into a lipstick.

Mixing lipstick is a three-step process. It begins with combining primarily castor oil with the powdered pigments. This results in a "liquid fudge" mixture that is then ground in a mill until very smooth (otherwise the pigments would be too abrasive for the delicate skin of the lips). This is a "primary pigment paste," according to M.A.C. Cosmetics' managing director and former chief chemist

Left: Lipstick Sandwich, *1995*

Victor Casale. The paste is made in every color and will later be combined with whatever wax a particular formula calls for. (Beeswax is soft, carnauba wax hard, and ozokerite wax somewhere in between.) The wax is melted and mixed with an emollient, chosen for the flavor, tackiness, or lubrication it will give the lipstick. Before the pigment is added to this new solution, the colors are mixed to achieve the desired shade. This is the most painstaking part of the process because it's an art as well as a science. All the ingredients are finally combined and heated to create a molten lipstick, which is then poured into molds and placed on a cooling table for approximately fifteen minutes. And voila! A new lipstick is born!

A good lipstick should have lasting color, go on smoothly, feel comfortable on the lips, be smear-proof, moisturize and soften, maintain its shade, and give a clear, nonfeathering outline. It's a tall order, but, unlike in the manufacturing of other cosmetics, poor formulation or processing does not go unnoticed (yes, you can tell the difference between a cheap and an expensive lipstick).

Although the basic recipe is quite simple, ingredients such as moisturizer, vitamin E, aloe vera, collagen, amino acids, and sunscreen have been increasingly added to lipstick in recent years. These extra components keep women's lips soft and moist—and further protect them from the elements. A University of Southern California study found that men were seven times more likely to develop lip cancer than women simply because women shielded their lips with lipstick.

There are three basic lipstick shapes used today, all variations on the classic bullet that first appeared in the late '30s, when manufacturers began searching for a format that was sturdier and easier to apply: the fishtail (angled on both sides of the tip); the teardrop (a pointed tip that is angled on one side); and the wedge (a more rounded tip angled on one side). The shape a manufacturer chooses has as much to do with the lipstick's particular formula as it does with aesthetics—how it appears in the brand's cosmetics casing.

Antique lipstick cases from Lancôme, undated

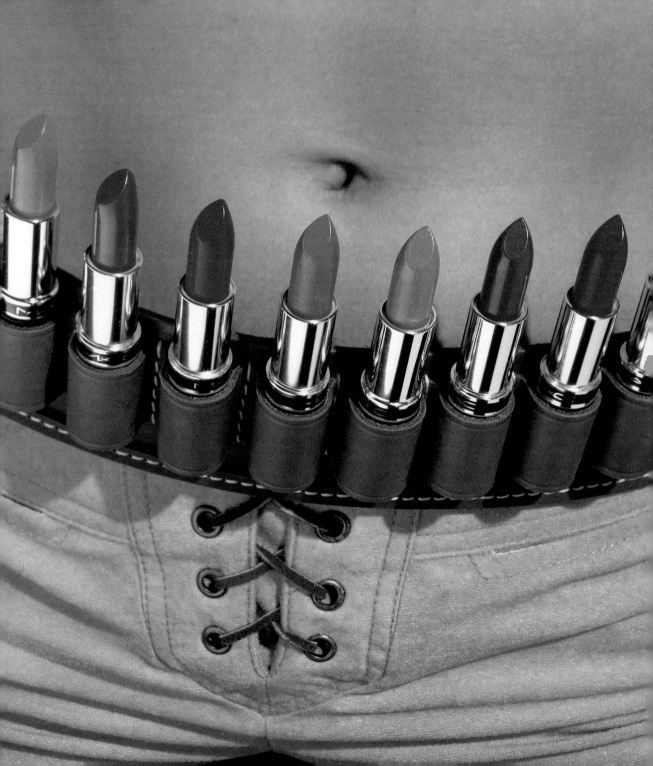

Lipstick's Lethal Past

Lipstick has come a long way since the days it delivered the kiss of death. Leading toxic ingredients included lead, mercury, arsenic, and vermilion. "These substances nearly always produce disastrous effects," a beauty writer warned in the early 1900s. "In fact, the texture of the lips is very sensitive and can hardly stand painting, and the productions destined to redden the lips only succeed in making the skin hard and wrinkled, and robbing it of all delicacy and pliancy."

After World War I, lipstick was little more than a greasy rouge made of dried and crushed insect bodies (for coloring), beeswax (for stiffness), and olive oil (for lubrication)—which had the unfortunate tendency to go rancid several hours after it was applied. Reformers who pushed for the passage of the Food and Drugs Act in 1906 were already concerned about the use of poisons in cosmetics. It wasn't until 1924, when the New York Board of Health considered banning lipstick—not, ironically, because of the harm it might cause the women who wore it, but out of fear that it might poison the men who kissed the women who wore it—that the government finally stepped in.

Even as recently as the '60s, lipstick was being made with harmful red dyes that stained the lips; a hint of hue lingered around the mouth long after the primary color had faded. These dyes have since been restricted for health and safety reasons, and their indelible effect has been achieved with the new, long-lasting lipstick formulas.

Left: Hipsticks, 1997

45

A Lexicon of Lipstick

Lipstick is bought for its texture, and different situations call for different lipsticks. "Think of the paint finishes you can buy—matte, high gloss, semi-gloss," says M.A.C. Cosmetics' Victor Casale. "They all translate into lipstick formulas: a matte paint equals a matte finish, a semi-matte equals a creme, a satin equals a satin, and a gloss equals a gloss." Here's the lowdown on the most popular lipstick preparations.

Mattes: Heavy in wax and pigment but lighter in emollients, these are for women who want a lot of texture without the shine. Usually wear longer than your average lipstick. Added moisturizers help combat the drying, cakey effects of the original versions and allow for more even distribution of color.

Cremes: Often considered the most popular finish in the lipstick family for their balance of shine and texture. Added oils give them a touch more sheen than a matte, but not as much glisten as a true gloss.

Glosses: Lots of emollients mean high shine, low color. Because they're made with softer waxes, they're more likely to be packaged in pots than sticks. A more natural-looking alternative to mattes and cremes.

Sheers and Stains: These subtle formulas contain a lot of oil and a medium amount of wax. Similar to a gloss, but with a tad more color.

Shimmers: The '90s version of the '70s frost. The extra glimmer comes from mica or silica particles, or even ground fish scales.

Long-Lasting: Color that can survive your next cup of coffee or kiss. The secret ingredient is silicone oil, which seals color to your lips.

Lip Liner: Contains less emollient and more wax than a regular lipstick. Prevents lipstick from bleeding.

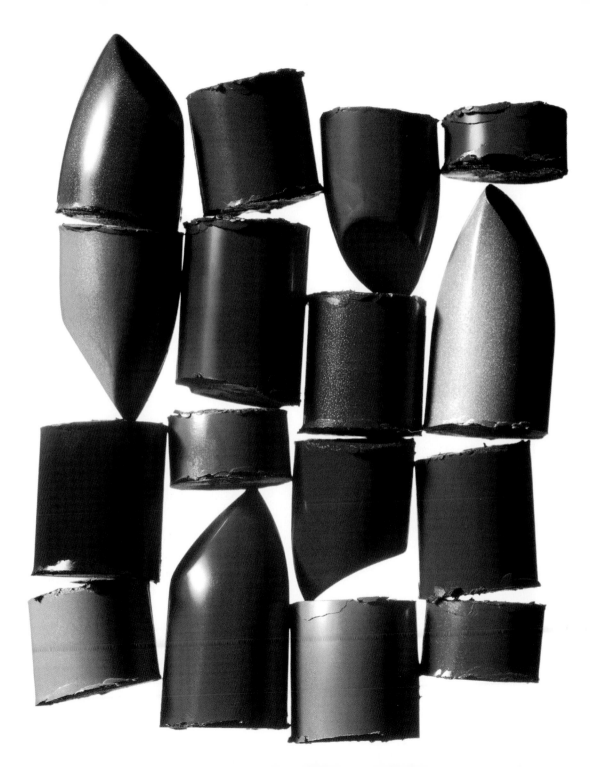

GUERLAIN

DARCY

THE LIPSTICK OF YOUR DREAMS

3 : The Business of Lipstick

On the surface, lipstick's coveted position as the best-selling cosmetic may be attributed to women's fascination with it; behind the scenes, its commercial success is credited to decades of creative marketing. Advertisers have succeeded in making lipstick the sexiest product on Madison Avenue. It can turn the girl-next-door into the siren on the silver screen, a wallflower into a seductress. The possibilities are limitless. That's lipstick's greatest draw.

Although the product had already been sold through such prestigious catalogs as Sears Roebuck in the late 1800s, it wasn't until after World War I, with the boom in consumer beauty culture and the increasing number of fashion magazines, that lipstick was first marketed with fearless abandon. Factories in Germany, France, and the United States ceased production of wartime resources in favor of more peaceful pursuits, which included, among other things, cosmetics. Women had gained new confidence after assuming men's work during the war, and they began competing with returning soldiers for jobs, boldly using lipstick to enhance their appearance and give them an edge on the competition. They outlined their lips with red, calling attention to the most sexually charged part of the face. One historian noted at the time that "with rouge, lipstick, powder, and nail polish, women could

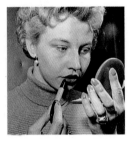

demonstrate that although they were not the women of twenty or fifty or a hundred years before, they were women just the same. Only different."

Advertisers began looking to Hollywood for their cues; actresses had been wearing lipstick in one form or another since well before the turn of the century. Movie stars made great spokespeople, and early ads resembled pin-up posters more than product endorsements. By the '30s, stars like Jean Harlow and Clara Bow were peddling lipstick for Max Factor in conjunction with the openings of their latest films. Ad campaigns were pushing youth and the natural look, a marketing philosophy that is still in practice today. In 1932, the cosmetics line Seventeen seduced women with the slogan, "Be Seventeen Tonight," promising "lipstick, in youth-tone shades that have no relation to the harsh, artificial coloring you've seen and loathed." Tangee took the less-is-more approach in 1938, proclaiming "natural lips more kissable," and guaranteeing them "a soft, natural glow that men find irresistible." Guerlain, in a departure foreshadowing sales tactics of the future, boldly advertised fantasies. One ad promised "the lipstick of your dreams."

Some advertisers responded to social changes by incorporating them into their campaigns. During World War II, a Tangee ad entitled "War, Women, and Lipstick" proclaimed: "It's a reflection of the free democratic way of life that you have succeeded in keeping your femininity even though you are doing a man's work. . . . No lipstick—ours or anyone else's—will win the war. But it symbolizes one of the reasons why we are fighting."

Demand for cosmetics was holding firm. In 1941, the *New York Times* reported that American women purchased $20 million worth of lipstick per year. Manufacturers still spent 20 percent of their income on advertising, but they responded to wartime austerity by shifting the emphasis from glamour and romance to "the importance of keeping war workers looking their best." Rosie the Riveter, the American poster girl for the war effort, was

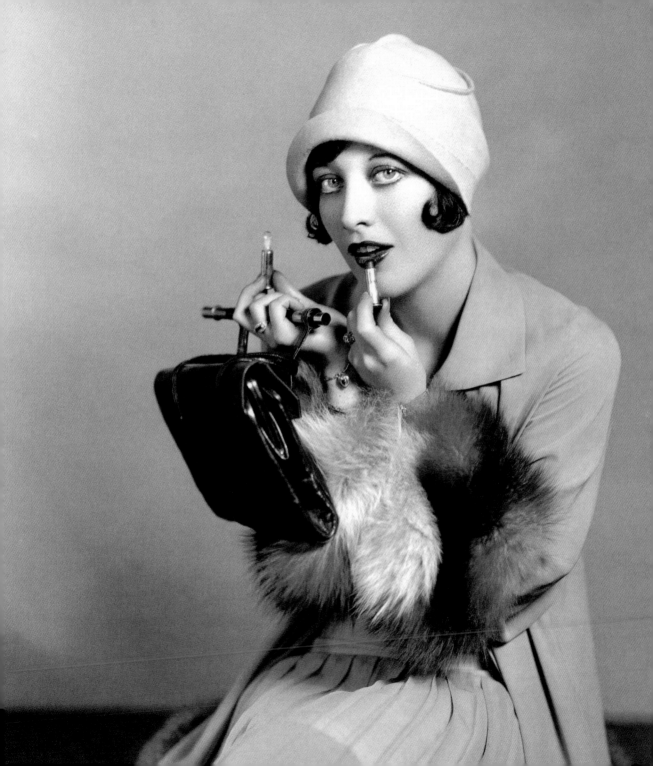

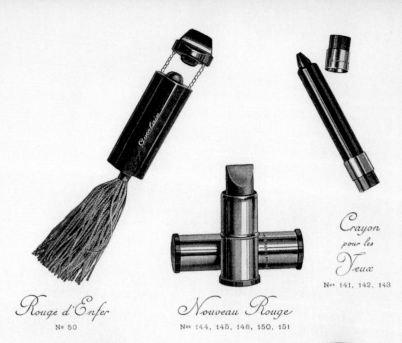

Rouge d'Enfer
Nº 50

Nouveau Rouge
Nᵒˢ 144, 145, 146, 150, 151

Crayon pour les Yeux
Nᵒˢ 141, 142, 143

Ne m'oubliez pas
Nº 452

Rose Lip Bengale
Nᵒˢ 640, 638, 639

Ne m'oubliez pas
Nº 588

shown dressed in denim work clothes and a tool belt—but nonetheless wearing lipstick.

Despite the war, overall sales of cosmetics increased by 65 percent in the United States and promised to increase more rapidly in the future even though many essential ingredients weren't available. Revlon joined the lipstick parade in 1940, selling "class to the masses"—fashion for the price of a lipstick. In 1946, Americans spent nearly $30 million for five thousand tons of lipstick—or, as *Life* so aptly put it, "enough to pay the president's salary for 77 years."

Max Factor boosted America's spirits by continuing to feature Hollywood in his ads: Ella Raines and Madeleine Carroll sold Tru-Color lipstick, in which "the color stays on through every lipstick test." Revlon launched its breakthrough Fatal Apple campaign in 1945, with Dorian Leigh in the role of Eve. It promised "the most tempting color since Eve winked at Adam." Revlon's semiannual "matching lipstick and nail polish" promotions were "as much of an event to women as Detroit's new-car introductions were to men," according to Kate de Castelbajac in *The Face of the Century: 100 Years of Makeup and Style.*

By the 1950s, lipstick had become the darling of Madison Avenue. A survey showed that 98 percent of women used lipstick; only 96 percent brushed their teeth. Advertisers were mimicking the "editorial look," creating ads that told a visual story and closely resembled the spreads you'd find in the leading fashion magazines. Max Factor introduced Clear Red in three distinct shades for "blondes, brownettes, and brunettes," modeled by fetching young Elizabeth Taylor, and Raymond Spector invested $1.5 million, the largest sum ever lavished on a lipstick, on chemist Hazel Bishop's "new lipstick that stays on—and on—and on!" But Revlon topped this in 1952, when it launched Fire and Ice, the most successful and most daring advertising

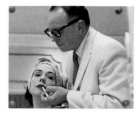

"If I have a date, give me a push-up bra and a tube of lipstick and I'm set to go."
Sandra Bullock, *In Style,* May 1998

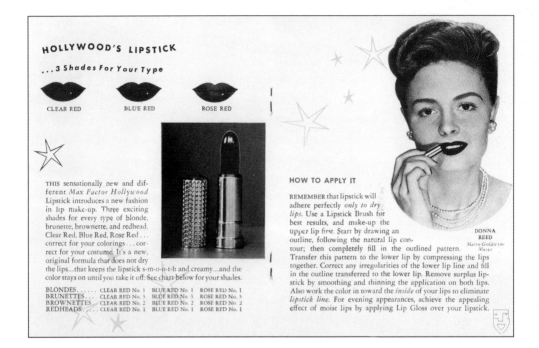

HOLLYWOOD'S LIPSTICK

...3 Shades For Your Type

CLEAR RED BLUE RED ROSE RED

THIS sensationally new and different *Max Factor Hollywood* Lipstick introduces a new fashion in lip make-up. Three exciting shades for every type of blonde, brunette, brownette, and redhead. Clear Red, Blue Red, Rose Red . . . correct for your colorings . . . correct for your costume. It's a new, original formula that does not dry the lips...that keeps the lipstick s-m-o-o-t-h and creamy...and the color stays on until you take it off. See chart below for your shades.

HOW TO APPLY IT

REMEMBER that lipstick will adhere perfectly *only to dry lips.* Use a Lipstick Brush for best results, and make-up the upper lip first. Start by drawing an outline, following the natural lip contour; then completely fill in the outlined pattern. Transfer this pattern to the lower lip by compressing the lips together. Correct any irregularities of the lower lip line and fill in the outline transferred to the lower lip. Remove surplus lipstick by smoothing and thinning the application on both lips. Also work the color in toward the *inside* of your lips to eliminate *lipstick line.* For evening appearances, achieve the appealing effect of moist lips by applying Lip Gloss over your lipstick.

DONNA REED
Metro-Goldwyn-Mayer

BLONDES	CLEAR RED No. 1	BLUE RED No. 1	ROSE RED No. 1
BRUNETTES	CLEAR RED No. 3	BLUE RED No. 3	ROSE RED No. 3
BROWNETTES	CLEAR RED No. 2	BLUE RED No. 2	ROSE RED No. 2
REDHEADS	CLEAR RED No. 1	BLUE RED No. 1	ROSE RED No. 1

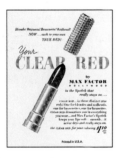

campaign in cosmetics history. The two-page ad featured the dark-haired beauty Dorian Leigh in a silver-sequined dress and a scarlet wrap. The headline read, "Are you made for Fire and Ice?" An accompanying "test" of fifteen questions promised that if you answered "Yes" to eight of them, then indeed you were. "Fire and Ice marked a new height in an industry where advertising is an all-important ingredient," reported *Business Week*; *Advertising Age* voted it the best campaign of the year. Lipstick had never looked better. Finally, there was a red with real meaning that captured the feminine spirit, the good and bad nature of women. It was a national phenomenon: Fire and Ice quickly became Revlon's most popular color.

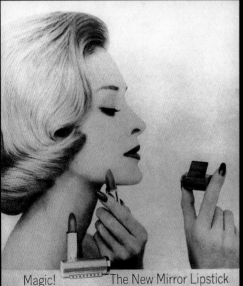

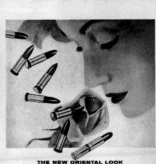

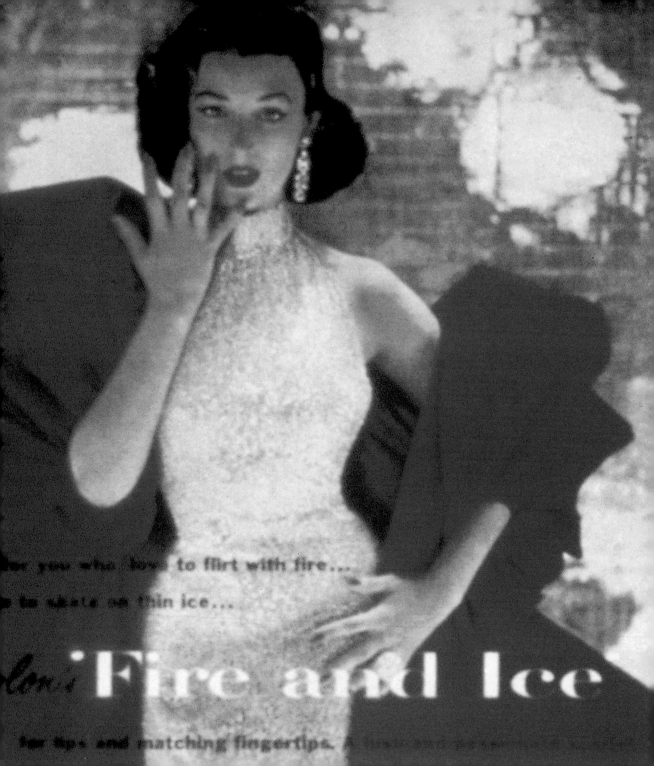

Are You Made for (Fire) and (Ice)?

Have you ever danced with your shoes off?

Did you ever wish on a new moon?

Do you blush when you find yourself flirting?

When a recipe calls for one dash of bitters, do you think it's better with two?

Do you secretly hope the next man you meet will be a psychiatrist?

Do you sometimes feel that other women resent you?

Have you ever wanted to wear an ankle bracelet?

Do sables excite you, even on other women?

Do you love to look up at a man?

Do you face crowded parties with panic—then wind up having a wonderful time?

Does gypsy music make you sad?

Do you think any man really understands you?

Would you streak your hair platinum without consulting your husband?

If tourist flights were running, would you take a trip to Mars?

Do you close your eyes when you're kissed?

Across the Atlantic, Lancôme was making waves with its innovative marketing strategies. At the Paris premiere of *A Streetcar Named Desire* in 1952, the French cosmetics company launched a lipstick of the same name, which was handed out to the crowd. Meanwhile, an old cable car cruised the streets of Paris with pretty girls on the back platform, publicizing—and wearing—the seductive shade.

The Lipstick Wars

The playing field was getting crowded. By the middle of the 1950s, there were four dozen brands of lipstick on the market and not a whole lot to distinguish among them. Thus, manufacturers felt a growing need to make their products stand out. Revlon launched its new Lanolite lipstick, the "only non-smear type lipstick which would last overnight and permit the user to wake up beautiful," and LOVE THAT PINK, "not a shy pink . . . a showoff pink! Not a whisper pink . . . a whistle pink!" Elizabeth Arden debuted The New Oriental Look, offering "exquisite makeup that blends the magic and mystery of the East." Mary Kay and Avon delivered lipstick right to your door in a pink Cadillac or with the now famous greeting, "Avon calling."

The competition was so fierce—and the stakes so high—that there was some foul play between companies. Hazel Bishop, who was holding court as the country's leading lipstick manufacturer, discovered that her phones had been tapped, presumably in an effort to steal trade secrets. (Revlon, the prime suspect, was never proven guilty.)

Advertising was so influential that if a lipstick promised to make the wearer feel bold, beautiful, and desirable, she'd most likely buy it. "Two identical lipsticks, marketed under different brand names, may have very different values for a teenage girl," said one advertiser at the time. "Wearing one of them, she feels her ordinary self; wearing the other, which has been

GUCCI

sunglasses

successfully advertised as the high road to romance, she feels a beauty—and perhaps she is." The success of the Fire and Ice campaign lay largely in the fact that women wanted to be the Fire and Ice girl—daring, sexy, just a little bit bad. Dorian Leigh was the quintessential "1952 American beauty with a foolproof formula for melting a male"; even the plainest of Janes could have a taste of her glamour for the price of a lipstick.

The Name Game

While advertisements lured new customers, the products themselves became more alluring. Mary Quant, who had introduced a new line of cosmetics for the mod 1960s fashion crowd, also revolutionized traditional cosmetics packaging, replacing the overly feminine pastel makeup cases with graphic black and silver containers. Quant created the coveted Paint Box: a square black box containing a one-stop makeup shop, including lip salve and a lip brush. She followed in Revlon's footsteps, further popularizing the notion of using playful, witty names for products. In the 1970s, Quant debuted her Makeup to Make Love In line because, according to Quant creative advisor Sue Steward, she "wanted to produce a range in which a girl could kiss and cuddle without looking smudged and frightful."

Quant's catchphrases set the groundwork for the naming trend that has taken a firm hold of the cosmetics industry and branded lipstick in the '90s. Carol Shaw, makeup artist and founder of Lorac, names her colors after celebrity clients, places, and things that inspire her. "Each lipstick tells a story," she says. "I have a color called Sedona and one called Desert Clay because I've spent a lot of time in Sedona and love the desert." For BeneFit's spring '98 line, cofounder Jean Ford Danielson came up with a series of random words describing everyday things. "We're going to have 'Like,Uh,' 'Dipstick,' and 'Padidle,' you know, for when one headlight of your car is

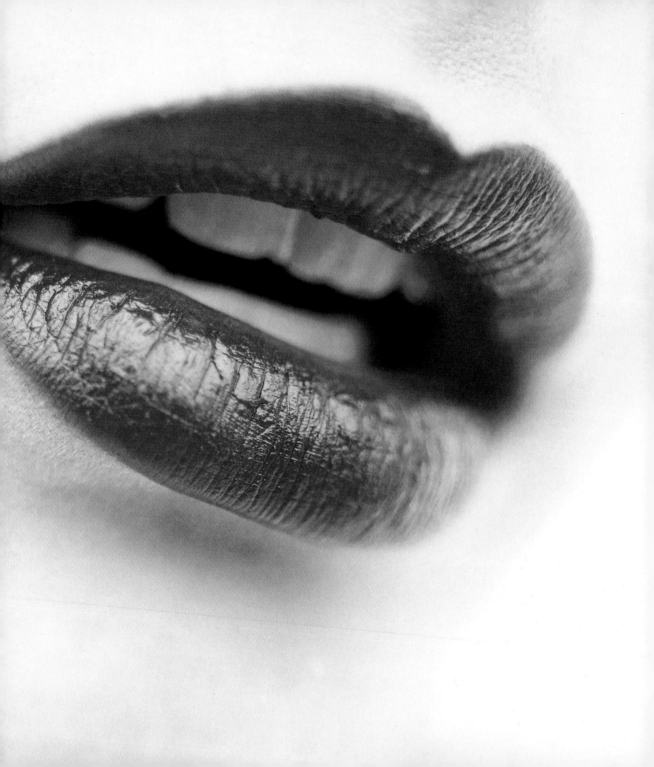

What's in a Name?

Since the 1940s, cosmetics manufacturers have recognized the appeal of assigning playful names to their products. Revlon kicked off this trend with Fatal Apple, Fire and Ice, and Cherries in the Snow. But today's monikers are even more witty and daring than their predecessors. And the stories behind their conception are just as captivating.

Name	Company	Inspiration
Indecent Exposure; But, Officer	BeneFit	"I had just gotten out of traffic school, so the line was all about things you could get arrested for," says Jean Ford Danielson, cofounder of BeneFit. "But, Officer is a real ingenue color, a fleshy tone, like you're really innocent."
Schizo	Hard Candy	"It's a dark, dark, dark, intense purple, something a psychopath would wear," says Dineh Mohajer, founder of Hard Candy.
Anjelica, Demi, Julia, Meg, Geena	Lorac	"It's my tribute to the powerful women I truly admire and adore," says Carol Shaw, founder of Lorac.
Heat Wave, Sun Bathe, What a Peach	Origins	"These names are for a collection called Mother's Other Nature, a saucier, sexier side of Mother Nature," says Daria Myers, vice president of marketing for Origins.

out," Danielson explains. "We stylize our lipsticks with these names because it's theater. We want to send customers out the door laughing." No one understands the alluring power of a name better than newcomer Dineh Mohajer, whose Hard Candy line puts a harder-edged, Gen-X spin on lipstick. "You don't want a lipstick called Really Raspberry or Soft Petal Pink," she says. "That's lame. We have a baby-blue metallic color that's called Sky—it's so fitting—and a metallic silver called Trailer Trash because metallic colors are sort of cheesy by nature, and yet at the same time they're kind of happening."

"The name of a lipstick is like hope in a tube," says Debbie Then, a social psychologist who specializes in women and physical appearance. "If there were several brands in the same color range, I'd definitely be swayed by the name."

Going for the Gloss

Burning bras and equal rights weren't the only products of the feminist era. Lip gloss—"barely there" color with lots of shine—was the industry's salute to the growing number of women who were shying away from in-your-face color, which they rejected as being either too feminine or too subordinate. (For those lingering lipstick fans, however, gloss was an added bonus that, when worn over their color of choice, achieved an ultraglamorous glow à la Diana Ross.) Some companies favored flavored formulas such as Maybelline's Cherry Smash Kissing Potion, and Bonne Bell's Bubble Gum, Root Beer Float, and Mango Lip Smackers, which were popular with teenage girls and left a sweet trace on their boyfriends' lips. Bonne Bell introduced its oversized Lip Smackers in 1973; it's still the world's best-selling flavored lip gloss.

Glosses have made a comeback in the '90s, with companies like Clinique, Kiehl's, Prescriptives, and Origins resurrecting the natural look and packaging the gooey glaze in everything from pots to tubes with applicators.

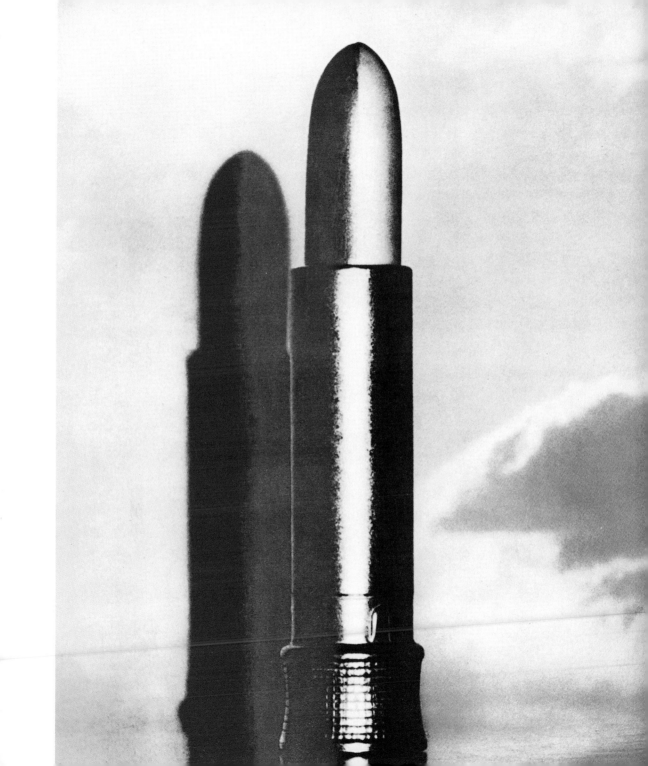

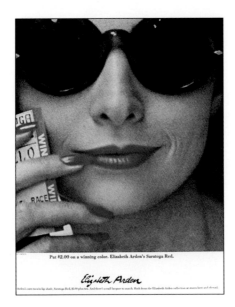

Put $2.00 on a winning color. Elizabeth Arden's Saratoga Red.

Elizabeth Arden

Arden's new terrific lip shade, Saratoga Red, $2.50 plus tax. And there's a nail lacquer to match. Both from the Elizabeth Arden collection at stores here and abroad.

Lip gloss was among the strongest growth categories for the first eight months of 1997, due primarily to the outrageous success of Lancôme's Brio.

The Birth of the Beauty Boutique

The beauty business was growing, and its money-making potential wasn't lost on heavyweights outside the industry. Cosmetics giants Elizabeth Arden and Max Factor were acquired by unlikely candidates Eli Lilly (the pharmaceuticals company) and Norton Simon, respectively. These takeovers set the stage for a new wave of entrepreneurs who saw a need for more personalized, customized service. Suzanne Grayson, former director of product marketing at Revlon, started the Face Factory, inspired by a visit to a Baskin-Robbins. "Instead of trying out [ice cream] flavors, I imagined women trying out lipstick colors," she told the *New York Times* in 1977. Grayson developed 229 lipstick shades for women to taste test. Adrien Arpel, just eighteen years old, started an affordable, color-driven cosmetics line, including lipstick, and sold it out of her own salons.

But the biggest cosmetics marketing revolution was still to come. In the '80s, makeup artists became the gurus of glamour. Hired to create the trend-setting looks for celebrities on the screen and models on the runway, they soon attracted a loyal following clamoring for their homespun creations. Makeup artists had been mixing their own lipsticks for years; finally, in response to growing demand—both from their clients and within the industry—they began to market them. M.A.C.'s Frank Toskan led the movement, first opening up a shop for fellow makeup artists in Toronto in the mid 1980s, then expanding into mass production a couple of years later. "Lipstick was our first product because it was the easiest to make and the most frustrating to find," says Toskan, who cooked his first lipsticks on his kitchen stove. "I was looking for something that didn't exist, that stood up under the intensity of light, had a lot of wearing power, and didn't have to be reapplied every five minutes."

Others quickly followed suit. Bobbi Brown, Trish McEvoy, Laura Mercier, Jeanine Lobell, Carol Shaw, and François Nars all entered the cosmetics fray via their makeup artistry. "It's the vision of just one person as opposed to the big, faceless, nameless companies," Ed Burstell, head of the cosmetics department at Henri Bendel, told the *New York Times Magazine* in 1996. When Bobbi Brown couldn't find lipsticks she liked for magazine photo shoots, she began creating her own. "I don't like [it] when a woman walks into a room and all you see is a lipstick," Brown said in *Allure* in 1996. "I like to see a person." She started with ten shades and sold them out of one store; expecting to sell one hundred tubes in a month, she sold that many her first day. Shaw also cut her teeth on lipstick. "Farrah was my first," she says. "She had been wearing this pink that was discontinued, and when I was formulating my lipsticks I always had it in the back of my mind to do a pink for Farrah. And so I created one and she loved it and boom—that's how my first lipstick came about."

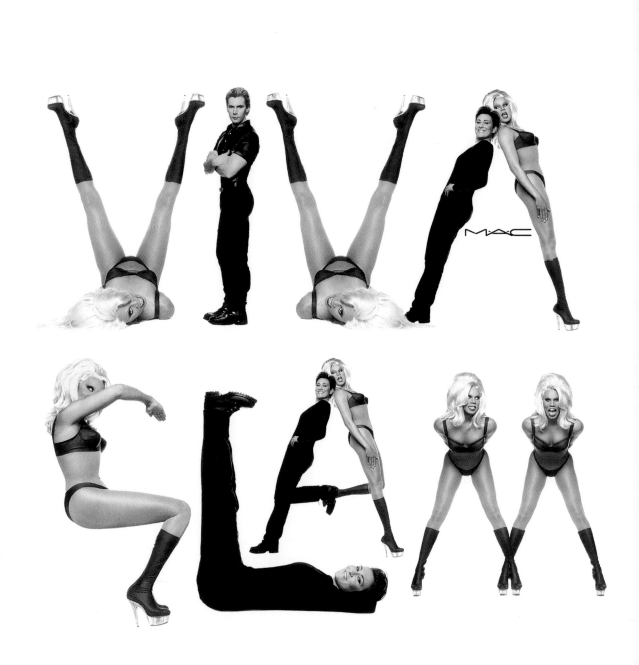

Reinventing the Rainbow

Making a better lipstick had as much to do with color as it did with consistency. As recently as twelve years ago, when Toskan was masterminding M.A.C., "lipsticks basically came in red, redder, and reddest, and pink, pinker, and pinkest," he says. Two predominant color palettes to paint the lips of millions of women. And few product lines addressed women of color. Toskan and the other makeup artists made it their business to fill in the browns, taupes, burgundies, blues, yellows, blacks, and silvers. Companies like Hard Candy and Urban Decay have taken the color game to new extremes by injecting a heavy dose of attitude into their products, and lipstick shades range from icy baby pink (Pussy Cat) to nude lavender (Nymph) to icy diamond (Narcotic). "We're all over the map today," says Toskan, "from the darkest purples and browns to the palest yellows and beiges. I think it's wonderful that lipsticks have ventured out into more unusual colors."

Buy a Lipstick, Save a Life?

As the cosmetics industry became more savvy in marketing its goods, it also became more environmentally and socially aware. Of all the cosmetics, lipstick has emerged as the poster-product for charitable causes ranging from AIDS research to breast cancer awareness. In October 1994, Clinique donated the proceeds from the sales of its top-selling lipstick, Berry Kiss Long Last, to the Breast Cancer Research Foundation. In the spring of 1996, the American Foundation for AIDS Research (AMFAR) hosted a "lip-stain auction" in which twenty-seven celebrities puckered up for charity—with Linda Evangelista's paper kiss fetching the highest bid of $1,000. Probably the leading ongoing cosmetics crusade is M.A.C.'s Viva Glam lipstick campaigns; they've raised over $10 million for the M.A.C. AIDS Fund, which distributes the money to various AIDS organizations. "We insisted that our retail part-

"If my face were a sentence, my lips would be the exclamation point at the end!"
RuPaul

71

ners also give up their profits," says Toskan. "Nobody makes any money on the product. That's why it's so successful: we pay for the lipstick, the packaging, the shipping. Our staff doesn't take a commission on it. A hundred percent of every penny that customers spend on that lipstick goes back to their community."

Toskan also takes this forward-thinking approach when it comes to M.A.C.'s environmental policy. The company sponsers a "Back to M.A.C." recycling program; customers get a free lipstick for every six empty tubes they return. It also shuns animal testing. "We stood up and said, 'We're a cruelty-free company' at a time when people were shopping at our counters in fur coats," Toskan says. A growing number of companies share this pro-planet philosophy: Origins, Aveda, and The Body Shop, among others, all manufacture lipstick with a conscience.

Without a Trace

In the race toward the millennium, the current lipstick rage is the new long-lasting, kiss-proof formulas. Maybelline's Great Wear Budge-proof Lipcolor promises to "lock on for hours," and Revlon's ColorStay Lipcolor "stays on . . . and won't kiss off on him." "The biggest complaint from women about lipstick is that it transfers," says Annemarie Iverson, fashion and beauty director of *Harper's Bazaar*. "They want to be able to put on a lipstick and go to work and have it be there eight hours later." Since Revlon's ColorStay first hit the shelves in mid-1994, it's been a huge commercial success. "It went from 0 percent market share to 14.8 percent in 1995," noted Paine Webber research associate Hari Chandra in the *CMR Special Report* in 1996. In response to its overwhelming popularity, almost all of the other major cosmetics manufacturers, including L'Oréal, Lancôme, Cover Girl, Max Factor, and Estée Lauder, have introduced their own last-all-day lipsticks.

4:

Courage. Strength. Glamour. Passion. Unlike any other cosmetic, lipstick has the power to transform, to seduce, to transcend. It's the 911 of cosmetics, the female equivalent of the power tie. It's a bright swipe in the dead of winter, a beckoning blur through the open window of a train as it pulls out of the station. "Lipstick is to the face what punctuation is to a sentence," Diane Von Furstenberg said in *Town and Country* in 1992. "It sets the tone and offers insight into the author's intent. . . . A glossy fire-engine red lipstick is an exclamation point expressing a passionate nature; a soft matte pink is a semicolon that says something far more subtle." Its message is unique to the wearer: No two sets of lips are alike, and no two women wear lipstick in exactly the same way.

The act of applying lipstick is steeped in sexual meaning. For young girls, it's a coming of age, a way to make the passage from girlhood to womanhood. "Lipstick has more of a sexual connotation than other makeup," says social psychologist Debbie Then. "Mothers don't want their daughters tarted up with bright lips." Wearing lipstick makes the statement that the user is ready to engage in activities normally forbidden to children. "By smearing her lips the child says, This gives me the power to do what I

Left: Eight-carat Diamond Ring, *1995*

want," Joseph Hansen wrote in *Cosmetics, Fashions, and the Exploitation of Women*. In a 1959 episode of *Father Knows Best*, Kathy ("Kitten") struggles with shedding her tomboy ways and is advised by her mother that it's time "to put down the baseball bat and pick up the lipstick." But while adolescents are trying to achieve a false sense of maturity by experimenting with lip color, some psychologists see a woman's lip painting as a return to her rosebud infancy. "The lips of an infant are very red, much redder than those of an adult," says Rita Freedman, a clinical psychologist and author of *Beauty Bound*. "By applying lipstick, women are achieving an infantile look, mimicking the swollen lips of a nursing infant."

Freedman and other theorists are willing to take this analysis one step further, likening a painted mouth to the labia of a chimp in heat, or to the labia of a woman when she's sexually aroused. "During erotic arousal, lips become swollen, much redder, and more protuberant," wrote Desmond Morris in *Body Watching*. "The change they undergo mimics closely the alterations that are taking place on the other labia—of the female genitals. . . . It also explains why women have for thousands of years painted their lips red to make themselves more visually exciting." Thus, painted lips flash like neon signs advertising a woman's sexuality—they cry out exuberantly, "I'm ripe, I'm ready, I know what I'm supposed to do, and I'm willing to do it." (Furthermore, the ritual of applying a phallic-shaped tube to the lips, the most delicate and sensual part of the face, should not be lost on anyone.)

The Tug of the Tube

Lipstick's psychological grip on women was never more strongly felt than during wartime, when its mere presence was equated with morale. An article published in 1951 described it as the "most missed" beauty product during the world wars, adding that "Navy nurses evacuated from submarines

The Red Badge of Courage

Every age has its own courageous gestures. The knight drew his sword. The gallant threw down his glove. The seigneur coolly took his pinch of snuff. There is a modern gesture to be added to the list . . . a purely feminine gesture. When a woman has lost her lover, when a girl has lost her job, when the doctor has told his fatal news, when the luck is leaving, the dinner party flopping, the birth pains beginning, the scandal breaking, the storm striking, the other woman sailing by in triumph . . . the sudden streak of lipstick across the lips spells courage. It is not done frivolously, but resolutely, desperately, defiantly, even gaily, with the dash and dignity of a courageous heart. Before the dim dressing-table of the night club, in the noncommittal mahogany mirror of the doctor's waiting room, in the hushed half light of the night nursery, in the smart, hard glitter of the descending elevator, proud fingers wield their weapon. The act reinforces the spirit. The streak of red steadies trembling lips. For one poignant moment, the little stick takes on the significance of a sword.

Harper's Bazaar, 1946

included lipstick among the few personal items they took with them."
President Roosevelt shared an anecdote with cosmetics queen Helena
Rubinstein, which she recounted in her memoir, *My Life for Beauty*, of a
London woman carried out of a bombed building on a stretcher. Before
agreeing to let the ambulance attendant give her something for her
pain, she implored him to retrieve her lipstick. "It does something for
me," she told him.

With lipstick in tow, women felt they could accomplish anything; it
gave them the strength to survive hardship and maintain a positive outlook
in even the most desperate of times. No image is more revealing than that
of a Leningrad woman who, after spending a year underground during the
war, stepped from her hidden bunker into the sunlight and, first thing,
applied her lipstick. Unlike any other cosmetic, lipstick gives the gift of res-
urrection. Its empowering effect not only heightens a woman's sense of
renewal, it also validates her femininity and prepares her to compete in a
man's world. "Because it disarms without destroying, it is more sophisticated
than the latest electronic weapons," wrote Véronique Vienne in *Town &
Country* in 1992. "Busy working wives often used lipstick to 'draw the line'
when they dressed for the office. Bright lips signal to husbands the end of
morning intimacy."

Applying lipstick is like a reflex, a habit that is more innate than learned.
"I think lipstick's in our blood," says Linda Wells, editor-in-chief of *Allure*. "I
went to visit my niece when she was about two, and she decided to go
through my purse and found my lipstick, took the top off, swiveled it up, and
stuck it right on her lips." As much as a woman's love affair with painting her
lips is her birthright, it's also a ritual she performs until the end of her life. In
Betty Rollins's *Final Wish*, a memoir of assisted suicide, the author recounts that
before her mother took the fatal dose of pills, she asked to reapply her lipstick.

**"It seemed to me that [my
mother's] lips and lipsticks
conveyed signals like Morse
code: If I could read them, I
would know her."**
Dorothy Foltz-Gray,
Health, 1996

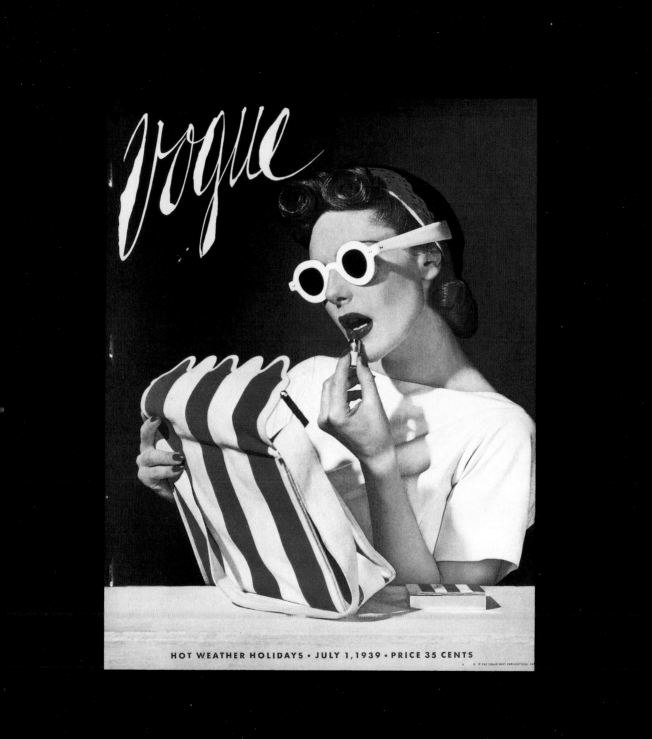

HOT WEATHER HOLIDAYS · JULY 1, 1939 · PRICE 35 CENTS

Smear Tactics

According to a 1996 survey by Shiseido Cosmetics, 87 percent of all American women over age twelve have left traces of lipstick where they didn't want to. In fact, one out of twelve who've left smudges on clothes they've tried on in department store dressing rooms have felt guilty enough to purchase the stained garments. But men are the most common targets for a woman's misplaced kiss. Here's the skinny on stray prints:

● 65.5 percent of all lip prints occur on husbands or boyfriends

● The number one lip print site on men is the face: 24.4 percent on the cheek; 9.8 percent on the lips; 3.3 percent on the nose; 2.4 percent on the forehead

● Men in their forties tolerate lipstick smudges the least; men in their fifties and sixties, the most

● 54 percent of men said women should wear lipstick that doesn't come off, be more careful, or wear no lipstick at all

The simple gesture of applying color to the mouth represents myriad emotions. It transforms a woman from her private to her public self, prepares her for the world with one quick smear of the waxy substance. "The swift lining of a mouth with lipstick is usually the last thing a woman does before she steps out of the house and into the street," wrote Maggie Angeloglou in *A History of Make-up*. "This macabre slash of red switches a woman into her outdoor self, removing her from the safe cell of the home, and into public life." When women step out in lipstick, anything can happen. The "come-hither" call of boldly painted lips is experienced by siren and wallflower alike. In a contemplative frame of mind? Then a lilac-pink may be in order, or per-haps a taupey-brown. The shade of lipstick a woman wears is an extension of her mood, her own private greeting or calling card. "I don't really feel like myself without lipstick," says author Elizabeth McCracken in the June 1997 issue of *Allure*. "I feel terribly disoriented until I put it on. . . . Let me put it this way: I put on lipstick before I go out to get the Sunday paper."

Lipstick's message also crosses genders, enhancing both a woman's and a man's femininity. A drag queen's identity is defined as much by the lipstick he wears as by his sequined dress or spike heels. In fact, RuPaul was chosen by M.A.C. Cosmetics to be the poster boy for Viva Glam, a matte red lipstick, one of the company's most popular shades. The term *lipstick lesbian* was coined by lesbians to show the world that all gay women were not the stereotypical short-haired, leather-clad dykes that mainstream society had come to expect. They use lipstick for the same reasons all women do—to attract a lover, enhance their sexuality, be noticed. "I learned to be sexy from my mother, lean-ing toward the mirror in her slip with a lipstick in her hand," wrote Su Penn, former publisher of *Lesbian Connection*, in an essay in *The Femme Mystique*. "I wanted to be sexy that way, my lipstick a challenge and a declaration: yes, I know I'm sexy. I dare you to look at me. I dare you to look away."

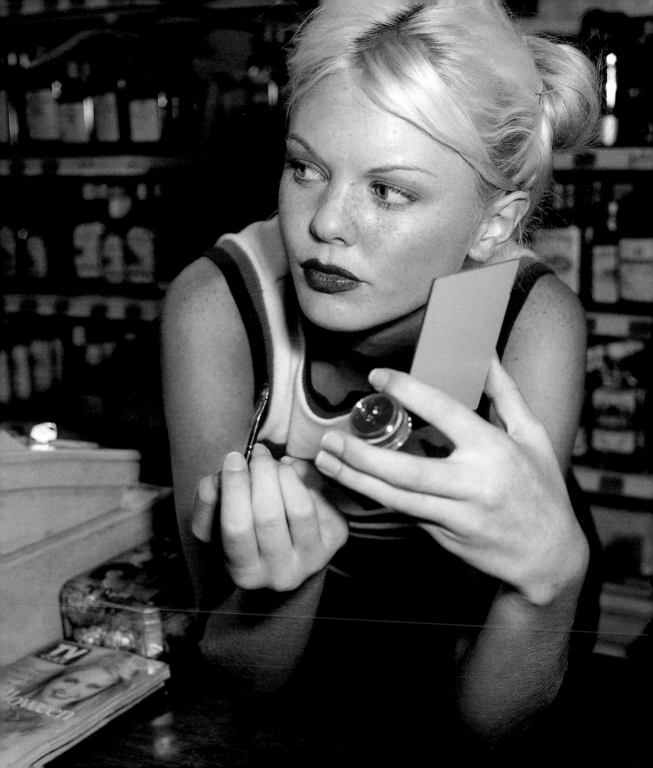

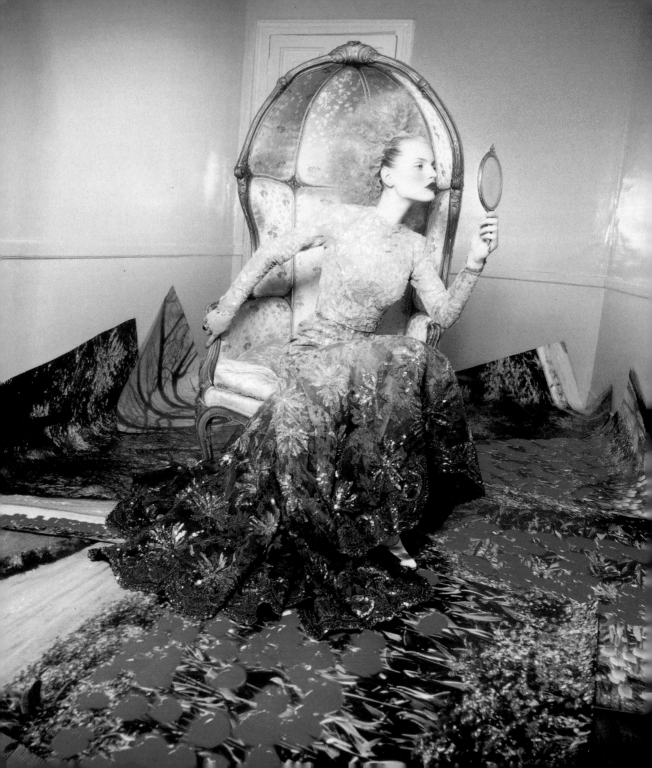

Lipstick Marks the Spot

For decades, cosmetics manufacturers have been churning out indelible, longlasting formulas, but one of lipstick's greatest legacies is its ability to leave a trace. Painted lips claim territory; they're a personal autograph. A lipstick smudge on a lover's collar, a cheek, a coffee cup, the end of a cigarette, a linen napkin, a pillowcase, a martini glass—this is the evidence a woman leaves behind. "Nasty, clinging lipstick has been the policeman that has kept men honest lo these long and dreary years," Paul Gallico wrote in "The Purloined Buss," which appeared in *Reader's Digest* in 1952. The simple sexiness of a single lip print can arouse suspicion or pique curiosity. "The tradition honored in song, pulp fiction, television, and film, of brushing the lips against the collar of a loved one, signaling (possibly to the wife of the loved one) sexual territory," wrote Mary Tannen in the *New York Times Magazine* in September 1994, is "the utterly female, impish and impetuous way of leaving our signature." Women wear lipstick because they want to be caught, remembered,

"[It's] the click that punctuates a good time. You've put on your lipstick and snap, excitement awaits."
Designer Cynthia Rowley describing the titillating "whoosh" of a tube's perfectly sealed lock-in, in *Harper's Bazaar*, 1995

Tube Talk

When it comes to lipstick, every woman has her own philosophy. Some swear by a single shade, others by an entire passel of colors. There's no singular approach to the tiny tube. Here's what a few of the experts had to say.

Annemarie Iverson, beauty and fashion director, *Harper's Bazaar:* "I'm very obsessive about lipstick. I go through phases where I have to have about seven tubes of the same color. I keep one in every pocket, in every bag. It's my magic lipstick, and the color changes about every six months."

Jean Godfrey-June, beauty and fitness director, *Elle:* "I approach lipstick the same way I approach music. I always have two albums that I'm obsessed with, and it's the same thing with lipstick. I have two that I carry at any given time until a new color comes along, rises to the top, and replaces one of them."

Linda Wells, editor-in-chief, *Allure:* "I carry six or seven lipsticks in my bag. They're all different colors, not a huge spectrum, but different shades of a slightly more intense color than my own lips. Most are different textures, and sometimes I feel like I found the one. I think, This is it, this is perfect, but then I move on to something different. I fall in love with each color at different moments so I have them all in my bag depending on my mood at that time."

Jean Ford Danielson, cofounder, BeneFit Cosmetics: "In your teens and your twenties you go for the hippest color that's also going to look good on you. In your thirties, you swing from one color to the next, you become a kind of lipstick junkie, going from line to line in search of the right lipstick. But when you're in your forties, you want a signature lipstick, a color you can buy three or four of and wear with everything. You usually wear that shade to the grave."

Laura Mercier, makeup artist and founder of Laura Mercier Classique: "I carry four lipsticks with me at a time. I always have my basic color—a brown-red sheer—my pale, muted brown-rose, my chocolate brown, and my red. Always something for every mood because I can never say which mood I'm going to be in. What I'm doing, where I'm going, determines which color I wear."

OCT. 15

VOGUE

BEAUTY
ISSUE

FOR THE WOMAN
WHO WANTS TO
CHANGE HER LOOKS

INCORPORATING
VANITY FAIR
50 CENTS
COPYRIGHT 1951
THE CONDÉ NAST PUBLICATIONS INC.

pursued, adored. It's a way of making one's desires known in a discretely indiscreet manner.

And yet this indiscretion has a price. Lipstick often deters a man from planting a wet one on his beloved's lips; it can make him hesitate, think, and think again. "I am depressed almost to tears at the thought of the billions and trillions of kisses that never happened because of that confounded red paste that women have been taught to smear upon their lips in the wackiest paradox of modern times," wrote Gallico. "Woman made her lips alluring with the very substance that makes it practically impossible to succumb to that allure."

Lipstick is a woman's secret, her fantasy, her device; it's a pleasure she steals for herself. Often it is lost on men. Mostly, it is lost on husbands, who prefer their wives in pink lipstick (or none at all)—and their mistresses in red. "It's the virgin-whore syndrome," says Annemarie Iverson of *Harper's Bazaar*. "Men are attracted to red lips, but once they have you they prefer you in pink." No one understands this paradox better than women—and since the earliest of times they've used it to their advantage. "When I want the entire love of one good man—the one I'm married to—I don't bother to use it," said the character Christel in "The Lipstick Mood," a short story that appeared in *Ladies Home Journal* in 1930. "But when I'm not so single-minded, out comes the old lipstick."

Lipstick's Holy Grail

"The search for the right lipstick is a never-ending quest," wrote Véronique Vienne in her essay "Read My Lipstick." "But lips are not easily satisfied—they're always thirsty." Quenching that thirst is more complicated than it may appear. The perfect color is elusive. It's always just out of reach, a shade away. And yet that's part of lipstick's appeal; it's what keeps women

Introduced last spring, Tony & Tina's new lipstick with St. John's Wort (an herbal alternative to Prozac) promises to brighten your lips—and your spirit.

"Lip prints are my graffiti, a little way of saying, 'I was here.'"
Elizabeth McCracken, *Allure*, June 1997

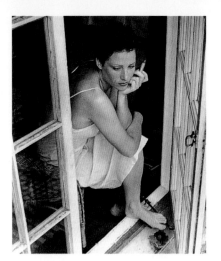

wrapped up in its mystique. "I think women hold out the notion that the answer to all their lipstick worries is out there," says Linda Wells. "It's this perfect shade that makes them look better than they ordinarily look. It's their lipstick holy grail." Those who are fortunate enough to find it, however, often live in fear that it will be discontinued. (Wells still mourns a Calvin Klein shade that came and went in the early '80s.) Others, well, can only dream. "If I could invent the ultimate color it would be called 'Perfect Shade,'" says Iverson. "It would be that perfect plummy, pinky, browny, neutral that, when I put it on, makes me look younger, thinner, taller, smarter, healthier. That's the dream of lipstick. If you choose the right color, it can do everything."

Most important, it's how lipstick makes you feel about you. "It's like your clothes, they make a statement about you to yourself," says *Elle* beauty and fitness director Jean Godfrey-June. "I'm not going to pull out a cracked-plastic [lipstick] container at a beautiful black-tie party," adds *Allure*'s Wells. A lipstick that looks good in public is usually a lipstick that feels right in your palm. Weight is an essential factor. Heavy enough so you're aware of its transformational powers yet light enough so you can take it anywhere, that's a lipstick that commands your attention—and will capture the attention of others.

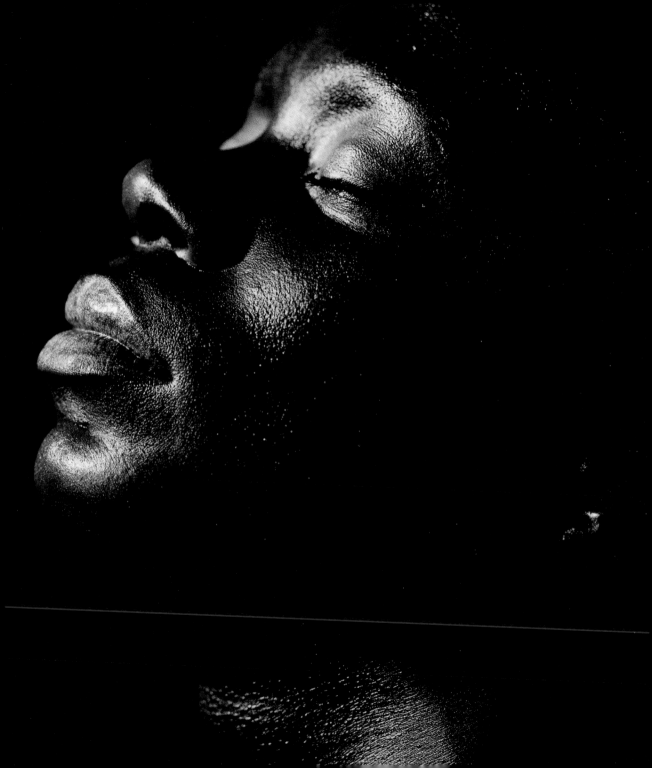

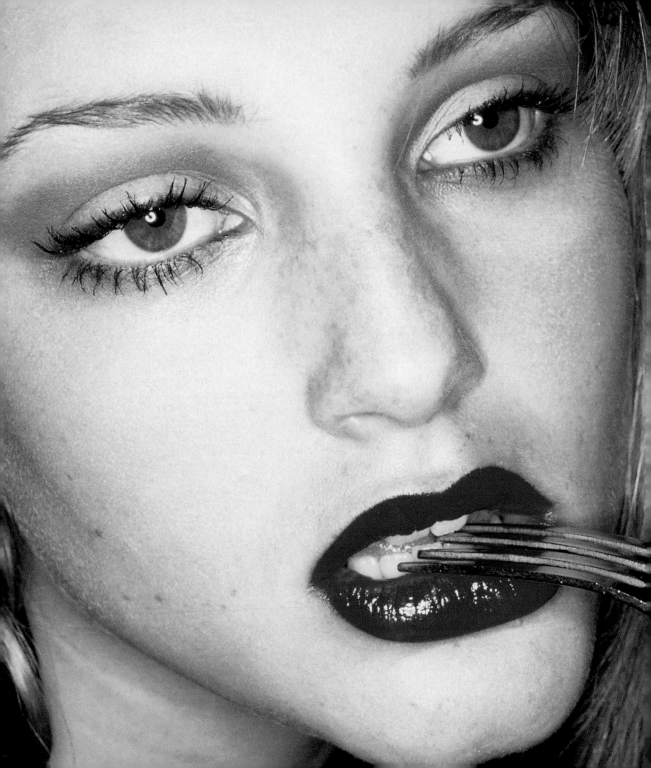

The Power of Red

Red lips mean business. Paloma Picasso knew it; she started wearing her trademark red when she was only three years old. And silent film stars made up for their lack of words with deep, darkly painted lips. For more than forty years, Fire and Ice, Cherries in the Snow, and Love That Red have been among Revlon's best-selling shades. When a woman dresses her mouth in scarlet veneer, she commands authority. Big personalities have always been synonymous with big, red-lipsticked lips: Female icons from Marilyn Monroe to Bette Davis to Lucille Ball made crimson-stained mouths an integral part of their image. Can you imagine Madonna expressing herself with anything other than a ruby-red kisser? "Red is the boldest of all colors," wrote Alexander Theroux in his 1994 book of essays, *The Primary Colors.* "It stands for charity, martyrdom, hell, love, youth, fervor, boasting, sin, and atonement." This range of associations speaks to its staying power: Red lip color is timeless, as appropriate today as when it first adorned Cleopatra's mouth.

The secret of its success is its contradictory nature. Both inviting and intimidating, red lipstick captures the feminine spirit. It always has the last word. "Red lipstick is the perfect final touch—like dropping a cherry into the rich dark amber of a Manhattan cocktail: complete, mouthwatering, and

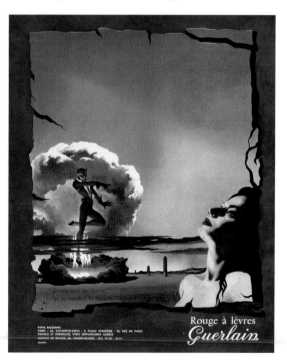

classic, all at the same time," wrote Lynn Snowden in *Mirabella* in 1997. Its pervasiveness gives it the ability to stand alone; nothing looks better than red lipstick on an otherwise makeup-free face.

"Pure red lipstick is as classic as a Chanel suit," says Linda Wells, editor-in-chief of *Allure*. "There are women who wouldn't wear anything else. But it also carries a certain responsibility with it." Women who paint their lips red should be prepared to be the center of attention, to speak up, to follow through; red lips have a certain in-your-face quality that can't be ignored. According to Theroux, just seeing the color red has been known to increase a person's metabolic rate by 13.4 percent. "Red, for all its sexiness, is the one color women will always come back to," says Dineh Mohajer, founder of Hard Candy. "It's a classic color," says Bobbi Brown, founder of Bobbi Brown Essentials. "It's a sophisticated look without needing a lot of other makeup."

But be warned: not everyone can wear red lipstick. You may be a blue-red or an orange-red, but few women are a true red. "Women who wear red lipstick have very meticulous personalities," says Wells. "You'll probably find that their closets are clean, their toenails are the perfect shape, they've taken care of all their correspondence and their desks are nice and tidy. You can't pull off a very intense red and be haphazard about it."

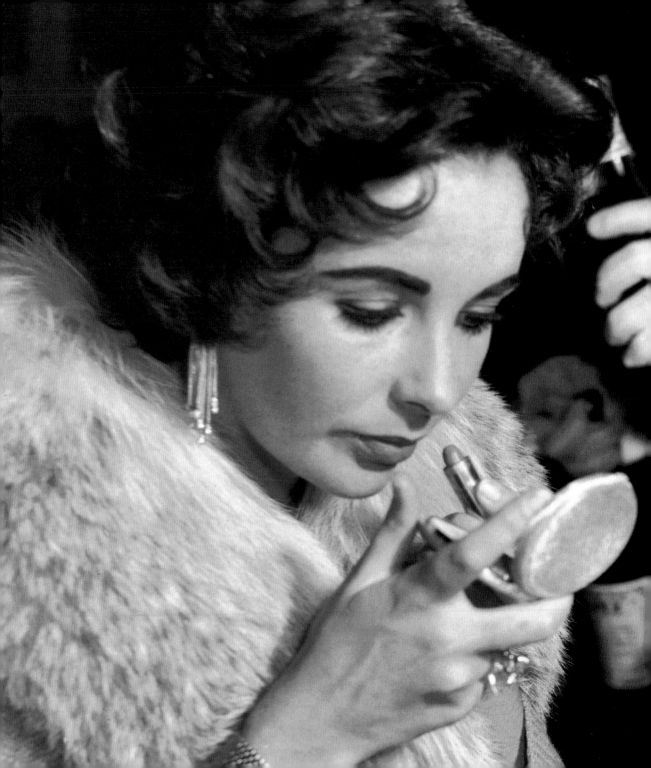

5:

For a device of such small stature, lipstick has inspired great things. It's become an integral part of our physical—and artistic—culture. Connie Francis crooned about lipstick on your collar and Man Ray immortalized red lips in *A l'heure de l'observatoire, les amoureux*. Lipstick has popped up in pop art in James Rosenquist's *Fahrenheit 1982* (1982) and *House of Fire* (1981) and surfaced in surrealism in Salvador Dali's *Mae West Lips Sofa* (1936–37) and *Lip Brooch* (1949). (In fact, *La Révolution Surréaliste,* [the second surrealist manifesto], published in Paris in 1929, bore multiple impressions of lips on its front—lipstick kisses—a frottage that prompted a succession of lip prints in various media.) Films are filled with meaningful, plot-crucial lipstick moments, which, with the advent of color film, have only become more spellbinding over time. Lipstick has changed lives, been an accomplice to crimes, broken up marriages, invited dreams, and shattered illusions. In every context, it changes meaning. But whatever the context, it always plays a significant role.

Building an Icon

One of the greatest artistic tributes to lipstick in recent years was its

Left: Preparing to meet the press, Elizabeth Taylor takes a moment to apply fresh lipstick, Rome, 1958

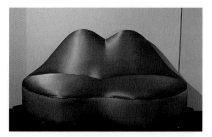

Clockwise from top: Mae West Lips Sofa, *1936–37, Salvador Dali; Poster for the San Francisco Museum of Modern Art's* Icons: Magnets of Meaning *exhibition, 1997; Man Ray's* A l'heure de l'observatoire, les amoureux, *1934. Oil on canvas*

Right: Lipstick (Ascending) on Caterpillar Tracks, *1969–74, Claes Oldenburg. Cor-Ten steel, steel aluminum, cast resin, painted with polyurethane enamel, 23'6" x 24'10½" x 10'11". Yale University, New Haven, Connecticut*

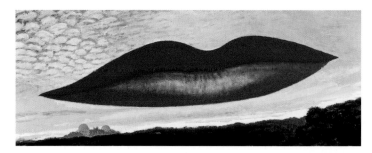

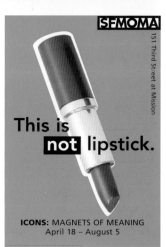

inclusion in the San Francisco Museum of Modern Art's 1997 exhibition *Icons: Magnets of Meaning.* Chosen as one of twelve objects that "are worth looking at, not because they are unique, but because they are so common-place," lipstick was selected because it had the "uh-huh" factor, according to the SFMoMA's architecture and design curator and the show's organizer, Aaron Betsky. "We sat around and suggested items, and if everyone said 'uh-huh,' it passed the test," said Betsky. "The response to lipstick was unanimous." That's because lipstick exists somewhere between adornment and implement; it maintains a certain ambivalence. It's a mask we wear to repel as much as to attract, a shield *and* an invitation. "We use lipstick in order to function," says Betsky. "It's part of the process of forming ourselves into objects that can withstand the changes of a complex society." It also captures

the sexuality that exists within the design environment; its phallic overtones combined with its overt femininity make lipstick the ideal icon. As it sits proudly within its perfectly designed container—a jewel presiding over its jewelbox—it commands authority, respect, and attention. Its simplicity embodies everything.

Claes Oldenburg thought so, too. When he constructed the sculpture *Lipstick (Ascending) on Caterpillar Tracks* at Yale University in 1969, he viewed

Above: House of Fire, *1981, James Rosenquist. Oil on canvas*

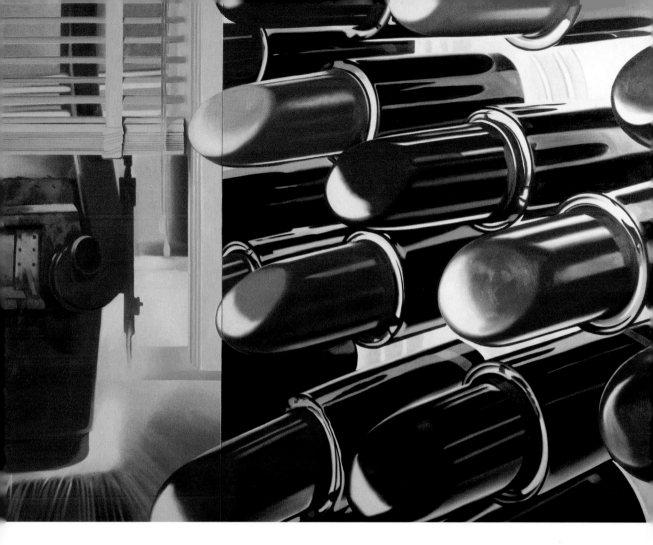

the "everyday object in its enigmatic nature as an icon of a culture." "Focusing on collective icons, on apparently banal objects and usages, he makes them tangible, soft, penetrable, and thus reconcilable with the human," wrote Germano Celant in an essay entitled "In and Out of the Bottle." Oldenburg had already installed a lipstick In London's Picadilly Circus in 1965 in response to the abundance of the color red—the buses, the telephone booths, the Underground cars. "When the Thames flows out, the lipstick goes back inside the tube; when

In her ongoing Lipstick series, New York artist Stacy Greene photographs lipsticks used by friends and acquaintances. "I see an everyday, factory, 'ready–made' product turned into a surreal, biomorphic, sub-conscious image—a sculpture evolving from a private daily ritual taken for granted," she says. The resulting images speak for themselves.

Roberta, 1993

Ellen, 1993

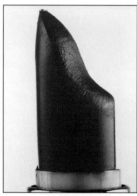

Maradee, 1993

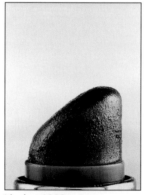

Linda, 1993

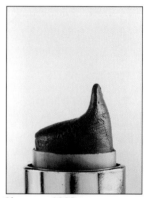

Simona, 1993

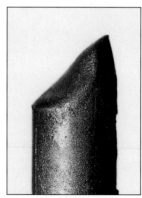

Brenda, 1991

Lisa, 1992

Beth, 1993

Rosie, 1992

Nancy, 1993

Jerelyn, 1992

Wendy, 1993

Magdalen, 1992

Stacy, 1992

Carolina II, 1992

Carol, 1992

Victoria, 1993

Top: Marilyn Monroe's Lips, *1962, Andy Warhol*

Below: Philip Johnson's Lipstick Building, New York City, 1985 (John Burgee, partner)

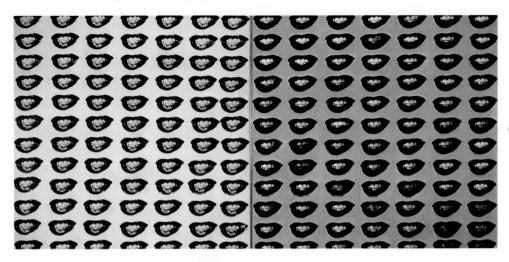

the river rises again, so does the lipstick," he said about the installation in Barbara Haskell's *Claes Oldenburg: Object into Monument.*

But perhaps the most famous lipstick monument is Philip Johnson's Lipstick Building in New York, on the corner of Fifty-third Street and Third Avenue. Completed in 1985, it became the new headquarters for John Burgee Architects with Philip Johnson. It was nicknamed the Lipstick Building "on account of its elliptical plan and the two setbacks in its elevation, which endowed its shaft with the look of a giant retractable lipstick tube," wrote Franz Schulze, in his book *Philip Johnson: Life and Work.*

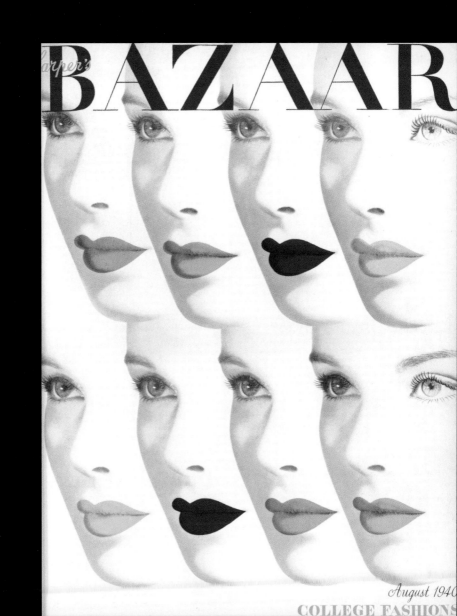

Harper's BAZAAR

August 1940
COLLEGE FASHIONS

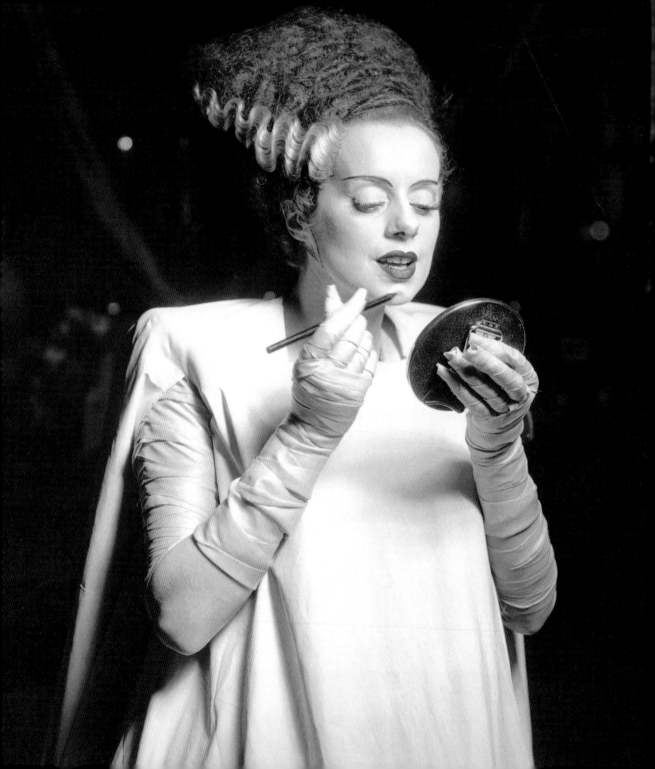

Lipstick on Location

Lipstick has shared screen time with some of Hollywood's greatest leading ladies. More than just a beauty enhancer, it sometimes plays a supporting role. By the end of Alfred Hitchcock's Lifeboat (1944), Connie Porter (Tallulah Bankhead) has survived countless life-shattering travails, including a shipwreck, near-starvation, and the loss of her treasured diamond bracelet. But when her ship finally comes in, she is positively panicked. "My nails, my hair, my face!" she screams, before whipping out her trusty lipstick and applying it hungrily to her mouth. In Dishonored (1931), agent X-27 (Marlene Dietrich) stands in front of a firing squad, proudly awaiting her death. While the drums roll, she makes the sign of the cross, then raises her veil, neatly applies her lipstick, and slips the tube back into her stocking. Pure class.

In 1976, Paramount released Lipstick, the story of a model made famous as the face of the cosmetics line, Lipstick. The film explores the consequences of using sex to sell product: Chris (Margaux Hemingway) is raped by the disturbed Mr. Stewart, who sees her racy advertisements as an invitation, as if selling lipstick is suggestive of selling herself, thus blurring the line between fantasy and reality. When he attacks her, he forces her to put on the very lipstick she peddles, saying, "I want to have it on me"—visible proof that he's "had her."

Lipstick's mission is sometimes to hide or reveal a woman's true nature. Nowhere was this better depicted on film than in Black Narcissus (1946), when Sister Ruth (Kathleen Byron) goes mad, gives up her vows, and provokes Sister Clodagh, her superior, by defiantly smearing lipstick on her mouth. When Eve White (Joanne Woodward) transforms herself into Eve Black in The Three Faces of Eve (1957), she discards her demure, mousy demeanor in favor of her spirited, chain-smoking, boozing, lipstick-wielding alter ego. In the last scene of Dangerous Liaisons (1988), when the Marquise de Merteuil (Glenn Close) is

"I often long for lipstick credits for movies. Let's face it: I don't care who the best boy was in The Client. What I really want to know is the name of that fetching brick red Susan Sarandon was wearing."
Elizabeth McCracken, "Test Tubes," Allure, 1997

booed from the concert hall after indirectly causing the deaths of both Madame de Tourvel and Vicomte de Valmont, she returns home, sits at her dressing table, and rubs the color from her face—and her ruby-red lips—as if removing her war paint after the battle.

Lipstick is often the first thing noticed about a woman—and the last thing remembered. In *The Postman Always Rings Twice* (1946), Cora (Lana Turner) announces herself by coquettishly rolling her lipstick into the cafe, where it stops strategically at her soon-to-be lover Frank's feet. (Later, when she dies in an auto wreck, her arm dangles limply from the car, her hand clutching a tube of lipstick.) In *The Breakfast Club* (1985), Claire (Molly Ringwald) shows off her most impressive talent: She tucks a tube of lipstick between her breasts, puts her chin to her chest, and applies the glossy veneer to her trademark pouty lips.

On screen, as in real life, women often depend on lipstick to revive them, to prepare them to face the world, or to recapture lost youth or femininity. In *Breakfast at Tiffany's* (1961), Holly Golightly (Audrey Hepburn), in a frenzy to get to Sing Sing, stops at her mailbox, where she has stashed a spare tube and

Above: Jack Lemmon and Tony Curtis in Some Like It Hot, *1959*

mirror, and reapplies her lipstick. Nikita (Anne Parillaud), in the French thriller *La Femme Nikita* (1990), is spared her life in exchange for service as an assassin for her government. While in the training program, she's taught by the mentoring Amande how to enjoy being a woman. Seated at a vanity, with Amande standing behind, watching her reflection in the mirror, Nikita applies her first smear of lipstick. "Let your pleasure be your guide," Amande instructs her disciple. "Your pleasure as a woman. And don't forget . . . there are two things that have no limit: femininity and the means of taking advantage of it." In Ang Lee's *The Ice Storm* (1997), Elena (Joan Allen), in an attempt to make herself feel young and desirable again, shoplifts a lipstick from the local drugstore.

One of lipstick's greatest roles may be its uncanny ability to convey a message loud and clear. Gloria (Elizabeth Taylor), in *Butterfield 8* (1960), makes quite a statement when she wakes up in the house of the married man she's picked up the night before to find an empty bed and $250 on the nightstand, which she assumes is for services rendered. Insulted and infuriated by the gesture, she looks into the mirror and pulls out her lipstick, but instead of applying

"Bette Davis with pink lips? Not even in a black-and-white movie."
Véronique Vienne, *Town and Country*, 1992

it to her lips, she scrawls NO SALE on the mirror and storms out—without the money—but wearing his wife's mink coat.

Lipstick's cinematic adventures haven't been reserved for actresses alone; some of the cosmetic's most memorable moments have happened on the mouths of men. Jack Lemmon and Tony Curtis dressed in drag—and in full makeup—in *Some Like It Hot* (1959), in which they posed as members of a female band to escape the mob. *La Cage aux Folles* (1978), and the 1996 remake *The Birdcage*, celebrates the art of cross-dressing; there was rarely an unpainted kisser on the screen. The cult phenomenon *The Rocky Horror Picture Show* (1975) featured a standout performance by Tim Curry as the mad scientist transvestite (Dr. Frank N. Furter) who favored, in addition to garter belts and sequins, brightly colored glossy lipstick. And Dustin Hoffman couldn't have sported a less flattering shade for his role as Dorothy in *Tootsie* (1982).

The Tube on the Tube

Lipstick has had its share of supporting roles on the small screen as well. Often it's used to distinguish between the homecoming queen and the girl who's been around the block one too many times. "Faster" femmes wear deeper, darker shades of lipstick and are frequently caught in the act of applying the seductive paint. Their goody-two-shoed rivals appear fresh faced and "barely lipped"—they revel in their makeup-free naïveté. Think of Ginger and Maryanne (tart vs. cutie pie), Serena and Samantha (bad witch vs. good witch), Veronica and Betty (rich bitch vs. poor do-gooder). On the *Brady Bunch* episode in which Marcia takes pity on the class wallflower, Molly, and makes her over, the "My Fair Lady" experiment spirals out of control: Molly, having tasted the thrill of lipstick for the first time, quickly dethrones Marcia as the high school sweetheart. Even on television, lipstick defines sexual boundaries and wields its transformational powers in an attempt to draw the line between naughty and

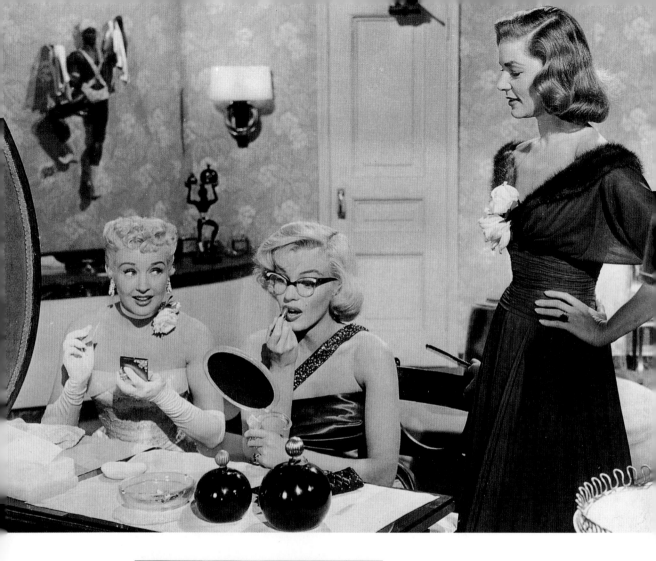

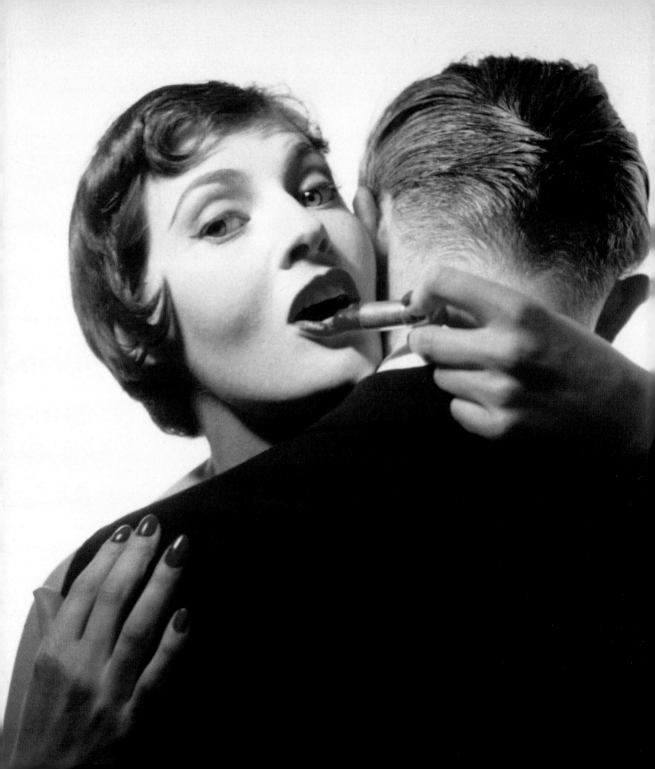

Connie Francis's "Lipstick on Your Collar" 1959

When you left me all alone, at the record hop.

Told me you were going out, for a soda pop.

You were gone for quite awhile, half an hour more.

You came back and man, oh man, this is what I saw.

Lipstick on your collar, told a tale on you.

Lipstick on your collar, said you were untrue.

Bet your bottom dollar, you and I are through.

'Cause lipstick on your collar, told a tale on you, yeah.

You said it belonged to me, made me stop and think.

Then I noticed yours was red, mine was baby pink.

Who walked in but Mary Jane, lipstick all a mess.

Were you smooching my best friend? Guess the answer's yes.

Lipstick on your collar, told a tale on you.

Lipstick on your collar, said you were untrue.

Bet your bottom dollar, you and I are through.

'Cause lipstick on your collar, told a tale on you, boy,

Told a tale on you, man, told a tale on you, yeah.

nice. Could you imagine Amanda Woodward *(Melrose Place)* or Alexis Carrington *(Dynasty)* with anything other than darkly painted lips?

Lipstick has also drawn the line between guilty and innocent, as it's made its way into the courts of TV law. In a 1996 episode of NBC's *Law & Order*, a woman's guilt is discovered when she's linked to the lipstick found at a crime scene. In this instance, art imitates life: The FBI keeps every shade and brand of lipstick on file, so if agents find a trace of lipstick during an investigation they can identify and match it to a suspect, in hopes of placing that person at the scene of the crime.

The Lyrics of Lipstick

Lipstick has not only provided visual inspiration, it's also left its imprint on the souls of song writers. A trademark that clearly characterizes a woman's feminine wiles, lipstick overwhelms, torments, and causes general chaos. Probably the most famous musical reference to lipstick is Connie Francis's "Lipstick on Your Collar" (1959), in which she chirps that it "told a tale on you." Once again, lipstick tips off infidelity and deceit. Elvis Costello complained of "not just another mouth in the lipstick vogue" in his angry anthem from the late '70s, "Lipstick Vogue." Pat Benatar jumped on the bandwagon in the early '80s with her manifesto to cheating men, "Lipstick Lies": "Lipstick lies won't hide the truth / They won't keep you waterproof / The victim of your vanity / You see just what you want to see."

The Wallflowers uphold the tradition of lipstick revealing a woman's sexual promiscuity. In "Three Marlenas," a song about the different faces of the mysterious Marlena, lipstick broadcasts the questionable behavior of a woman who's come undone: "Lipstick on her new dress / she hasn't even paid yet." Once again, the tempting tube has become the accomplice in another twisted tale of modern romance.

Select Bibliography

Books and Articles

Ackerman, Diane. *A Natural History of the Senses.* New York: Random House, 1990.

Angeloglou, Maggie. *A History of Make-up.* New York: The Macmillan Company, 1970.

Banner, Lois W. *American Beauty.* New York: Knopf, 1983.

Basten, Fred E. *Max Factor's Hollywood: Glamour, Movies, Makeup.* Los Angeles: General Publishing Group, 1995.

Brain, Robert. *The Decorated Body.* New York: Harper and Row, 1979.

Corson, Richard. *Fashions in Makeup: From Ancient to Modern Times.* London: Peter Owen Limited, 1972.

Dayagi-Mendeles, Mikhal. *Perfumes and Cosmetics in the Ancient World.* Jerusalem: Museum of Jerusalem, 1989.

De Castelbajac, Kate. *The Face of the Century: 100 Years of Makeup and Style.* New York: Rizzoli, 1995.

DeNavarre, Maison G. *The Chemistry and Manufacture of Cosmetics.* Orlando, Fla.: Continental Press, 1975.

Douglas, Susan J. *Where the Girls Are: Growing Up Female with the Mass Media.* New York: Times Books, 1994.

Foltz-Gray, Dorothy. "Lipstick: A Love Story." *Health*, September 1996.

Freedman, Rita. *Beauty Bound.* Lexington, Mass.: Lexington Books, 1986.

Hansen, Joseph, and Evelyn Reed. *Cosmetics, Fashions, and the Exploitation of Women.* New York: Pathfinder Press, 1986.

Lauder, Estée. *Estée: A Success Story.* New York: Random House, 1985.

McCracken, Elizabeth. "Test Tubes." *Allure*, June 1997.

Montez, Madame Lola. *The Arts of Beauty or Secrets of a Lady's Toilet.* New York: The Ecco Press, 1978.

Morris, Desmond. *Body Watching: A Field Guide to the Human Species.* New York: Crown Publishers, 1985.

Quant, Mary. *Quant by Quant.* New York: G.P. Putnam's Sons, 1966.

Reed, Julia. "Lipservice." *Vogue*, August 1994.

Snowden, Lynn. "Crimson Tide." *Mirabella*, September/October, 1997.

Theroux, Alexander. *The Primary Colors.* New York: Henry Holt and Company, Inc., 1994.

Tobias, Andrew. *Fire and Ice: The Story of Charles Revson, the Man Who Built the Revlon Empire.* New York: William Morrow, 1976.

Vienne, Véronique. "Read My Lipstick." *Town & Country*, September 1992.

Vinikas, Victor. *Soft Soap, Hard Sell: American Hygiene in an Age of Advertisement.* Ames, Iowa: Iowa State University Press, 1992.

Winter, Ruth. *A Consumer's Dictionary of Cosmetic Ingredients.* New York: Crown Publishers, 1976.

Credits

page 2: Thomas Heinser; page 6: Christine Alicino; page 12: Katigawa Utamara / Courtesy Corbis-Bettmann; page 14: Courtesy Corbis-Bettmann; page 15: *Vogue* cover, January 15, 1920. Courtesy The Condé Nast Publications, Inc.; page 16: A. de Neuville / Courtesy Corbis-Bettmann; page 17: Courtesy Corbis-Bettmann; pages 18, 19: Acme / Courtesy UPI / Corbis-Bettmann; page 21: Edward Steichen / *Vogue*, June 1, 1937. Courtesy The Condé Nast Publications, Inc.; page 22: Erwin Blumenfeld / *Vogue* cover, May 1945. Courtesy The Condé Nast Publications, Inc.; page 25: Clifford Coffin / *Vogue*, July 1951. Courtesy The Condé Nast Publications, Inc.; page 26: Courtesy Elizabeth Arden; pages 28–29: John Rawlings / *Vogue*, October 1, 1959. Courtesy The Condé Nast Publications, Inc.; pages 30, 31: Courtesy Cartier; page 33: John Rawlings / *Vogue*, February 1, 1959. Courtesy The Condé Nast Publications, Inc.; page 34: Sheryl Nields; page 36: Saul Leiter / *Harper's Bazaar*, July 1963. Courtesy *Harper's Bazaar;* page 37: © The Procter & Gamble Company. Used by permission; page 38: James Wojcik; page 41: Christine Alicino; page 42: still life: Thomas Card / *Harper's Bazaar*, September 1997. Courtesy *Harper's Bazaar;* inset: David Jensen / Jodi Rappaport Represents; page 43: top: Courtesy Lancôme; bottom: Mark Lund; page 44: James Wojcik; pages 45, 46: Bill Steele / Courtesy A+C Anthology; page 47: Brad Guice; page 48: Darcy, circa 1935 / Courtesy House of Guerlain; page 50: Courtesy UPI / Corbis-Bettmann; page 51: Courtesy Culver Pictures; page 52: Courtesy House of Guerlain; page 53: Dennis Stock / Courtesy Magnum Photos, Inc.; page 54: © The Procter & Gamble Company. Used by permission; page 55: clockwise from top: © The Procter & Gamble Company. Used by permission (1); Courtesy Elizabeth Arden (2, 3); page 56: Richard Avedon / Courtesy Revlon; page 59: Mario Testino / Courtesy Gucci; pages 60–61: David Bailey, 1985 / © Condé Nast PL / *Vogue;* pages 63, 64: Wolfgang Ludes; page 67: Bill Silano / *Harper's Bazaar*, April 1968. Courtesy *Haper's Bazaar;* page 68: Courtesy Elizabeth Arden; page 70: Courtesy M.A.C. Cosmetics; page 73: Michel Arnaud; page 74: David LaChapelle / Courtesy A+C Anthology; page 77: Wayne Maser / Courtesy A+C Anthology; page 78: David Bailey, *British Vogue*, July 1975 / © Condé Nast PL / *Vogue;* page 79: Man Ray Trust / Artist Rights Society (ARS) / Telimage, 1997; page 80: Steven Derry / Courtesy Culver Pictures; page 81: *Vogue* cover, July 1, 1939. Courtesy The Condé Nast Publications, Inc.; page 82: Mark Lund; pages 83, 85: Michael Edwards; page 86: David LaChapelle / Courtesy A+C Anthology; page 87: Albert Watson, *British Vogue*, August 1985 / © Condé Nast PL / *Vogue;* page 89: David Jensen / Jodi Rappaport Represents; page 90: Erwin Blumenfeld / *Vogue* cover, October 15, 1952. Courtesy The Condé Nast Publications, Inc.; page 92: Daniel Murtagh; page 93: Thomas Heinser; page 94: Ellen von Unwerth / Courtesy A+C Anthology; page 95: Courtesy House of Guerlain; page 96: Thomas Heinser; page 97: Cannonieri & Fortis / *Harper's Bazaar*, September, 1997. Courtesy *Harper's Bazaar;* page 98: Courtesy UPI / Corbis-Bettmann; page 100: clockwise from top: © Photo Descharnes & Descharnes / © 1997 Artist Rights Society (ARS); Courtesy Foote, Cone & Belding and the San Francisco Museum of Modern Art; Man Ray Trust / Artist Rights Soceity (ARS) / Telimage, 1997; page 101: Shunk-Kender / Courtesy PaceWildenstein, New York; pages 102–3: Courtesy Leo Castelli Gallery / © James Rosenquist / Licensed by VAGA, New York, NY; pages 104–5: Stacy Greene; page 106: top: Lee Stalsworth / Courtesy Hirshhorn Museum and Sculpture Garden, Smithsonian Institution; bottom: Richard Payne; page 107: Herbert Bayer, *Harper's Bazaar* cover, August 1940 / Courtesy *Harper's Bazaar;* page 108: Courtesy Kobal; pages 110, 111, 112, 113: Courtesy Photofest; page 114: William Klein / *Vogue*, April 1, 1955. Courtesy The Condé Nast Publications, Inc.; page 117: Helmut Newton / Vogue, October 1974. Courtesy The Condé Nast Publications, Inc.

Acknowledgments

It's time to kiss and tell. We want to thank a lot of people for bearing with us while we were busy making lipstick history:

To Don, for putting up with a lot of girl talk and for feeding us humor, support, and the best damn turkey tacos west of the Mississippi; Polly and Richard, for their unwavering confidence and tremendous generosity; Henry and Sylvia, for sending encouragement across the Atlantic; Arielle Eckstut, for her faith, enthusiasm, and sage advice; Christina Wilson, for shepherding us through the labyrinthian process; Carole Goodman, for her artistic guidance; David Slatoff and Tamar Cohen, for making our vision a reality; Véronique Vienne, for her lipstick expertise; Lenora Wiener, for her keen editorial sense and free room and board; Dorothy Marschall, for her visual inspiration; Dennis Golonka, for his immeasurable help, undying patience, and fat Rolodex; Julie Stern, for her tenacious research tactics (and for just being Julie Stern); Leigh Haddix, for her interest and dedication; Dian Aziza Ooka, for knowing that all a woman needs is a good pair of shoes and the right lipstick; Lisa Hilgers, for always lending an ear but never taking sides; Lisa Schermerhorn, for capturing our Kodak moment; Annaliese McDonald, for showing us how to apply lipstick—properly; and Jock McDonald, for always believing.

And a big smooch to the rest of the cast and crew who helped us along the way: Annemarie Iverson; Linda Wells; Jean Godfrey-June; Frank Toskan, Victor Casale, and Alison Saliani at M.A.C.; Bobbi Brown; Laura Mercier; Jean Ford Danielson; Carol Shaw; Dineh Mohajer; Thomas Heinser; James Wojcik; Christine Alicino; Michael Edwards; Mark Lund; Rita Freedman; Debbie Then; Aaron Betsky; Michael and Amy Cohen; Peter Cohen; Stephan de Rassy; Rosanna Sguera at Art + Commerce; Lisa Diaz at Condé Nast; Liz Stasney at *Harper's Bazaar*; Lisa Burns at Proctor & Gamble; Keiko at Betty Wilson Represents; Norman Currie at Bettman; the boys at Photofest; Dana Glazer Gers at Guerlain; Jadzia Zielinski at Revlon; Nancy Mindes at Elizabeth Arden; Alisa Katings at Lancôme; Colby Grimes at Origins; Mischa Kitain at Chrylon; Dale Johnson; Dorothy Foltz-Gray; Karmen Butterer; James Ragas; Jonathon Keats; Ken Fox; Tiffany Whitford; and all the artists and photographers who helped create the lush landscape for *Read My Lips*.